DATE DUE

OC 17 '02			
NO -6 '02			
NOV 26 2004			
GAYLORD			PRINTED IN U.S.A.

Draw 50

VEHICLES

Selections from
DRAW 50 BOATS, SHIPS, TRUCKS
AND TRAINS and DRAW 50 AIRPLANES,
AIRCRAFT AND SPACECRAFT

Lee J. Ames

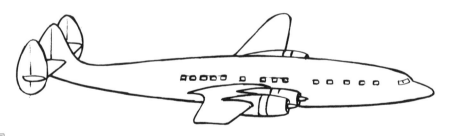

DOUBLEDAY

NEW YORK LONDON TORONTO SYDNEY AUCKLAND

A Main Street Book
PUBLISHED BY DOUBLEDAY
a division of Bantam Doubleday Dell Publishing Group, Inc.
1540 Broadway, New York, New York 10036

MAIN STREET BOOKS, DOUBLEDAY, and the portrayal
of a building with a tree are trademarks of Doubleday,
a division of Bantam Doubleday Dell Publishing Group, Inc.

ISBN 0-385-14154-8
Library of Congress Catalog Card Number

23 22

To the Reader

This book will show you a way to draw boats, ships, trucks, trains, airplanes, aircraft, and spacecraft. You need not start with the first illustration. Choose whichever you wish. When you have decided, follow the step-by-step method shown. *Very lightly* and *carefully*, sketch out step number one. However, this step, which is the easiest, should be done *most carefully*. Step number two is added right to step number one, also lightly and also very carefully. Step number three is sketched right on top of numbers one and two. Continue this way to the last step.

It may seem strange to ask you to be extra careful when you are drawing what seem to be the easiest first steps, but this is most important because a careless mistake at the beginning may spoil the whole picture at the end. As you sketch out each step, watch the spaces between the lines, as well as the lines, and see that they are the same. After each step, you may want to lighten your work by pressing it with a kneaded eraser (available at art supply stores).

When you have finished, you may want to redo the final step in India ink with a fine brush or pen. When the ink is dry, use the kneaded eraser to clean off the pencil lines. The eraser will not affect the India ink.

Here are some suggestions: In the first few steps, even when all seems quite correct, you might do well to hold your work up to a mirror. Sometimes the mirror shows that you've twisted the drawing off to one side without being aware of it. At first you may find it difficult to draw the boxes, triangles, or circles, or to just make the pencil go where you wish. Don't be discouraged. The more you practice, the more you will develop control. Use a compass or a ruler if you wish; professional artists do! The only equipment you'll need will be a medium or soft pencil, paper, the kneaded eraser and, if you wish, a compass, ruler, pen, or brush.

The first steps in this book are shown darker than necessary so that they can be clearly seen. (Keep your work very light.)

Remember, there are many other ways and methods to make drawings. This book shows just one method. Why don't you seek out other ways and methods to make drawings—from teachers, from libraries and, most important...from inside yourself?

LEE J. AMES

To the Parent or Teacher

"David can draw a jet plane better than anybody else!" Such peer acclaim and encouragement generate incentive. Contemporary methods of art instruction (freedom of expression, experimentation, self-evaluation of competence and growth) provide a vigorous, fresh-air approach for which we must all be grateful.

New ideas need not, however, totally exclude the old. One such is the "follow me, step-by-step" approach. In my young learning days this method was so common, and frequently so exclusive, that the student became nothing more than a pantographic extension of the teacher. In those days it was excessively overworked.

This does not mean that the young hand is never to be guided. Rather, specific guiding is fundamental. Stey-by-step guiding that produces satisfactory results is valuable even when the means of accomplishment are not fully understood by the student.

The novice with a musical instrument is frequently taught to play simple melodies as quickly as possible, well before he learns the most elemental scratchings at

the surface of music theory. The resultant self-satisfaction, pride in accomplishment, can be a significant means of providing motivation. And all from mimicking an instructor's "Do-as-I-do..."

Mimicry is prerequisite for developing creativity. We learn the use of tools by mimicry. Then we can use those tools for creativity. To this end I would offer the budding artist the opportunity to memorize or mimic (rotelike, if you wish) the making of "pictures." "Pictures" he has been anxious to be able to draw.

The use of this book should be available to anyone who *wants* to try another way of flapping his wings. Perhaps he will then get off the ground when his friend says, "David can draw a jet plane better than anybody else!"

LEE J. AMES

Draw 50
VEHICLES

Cabin cruiser

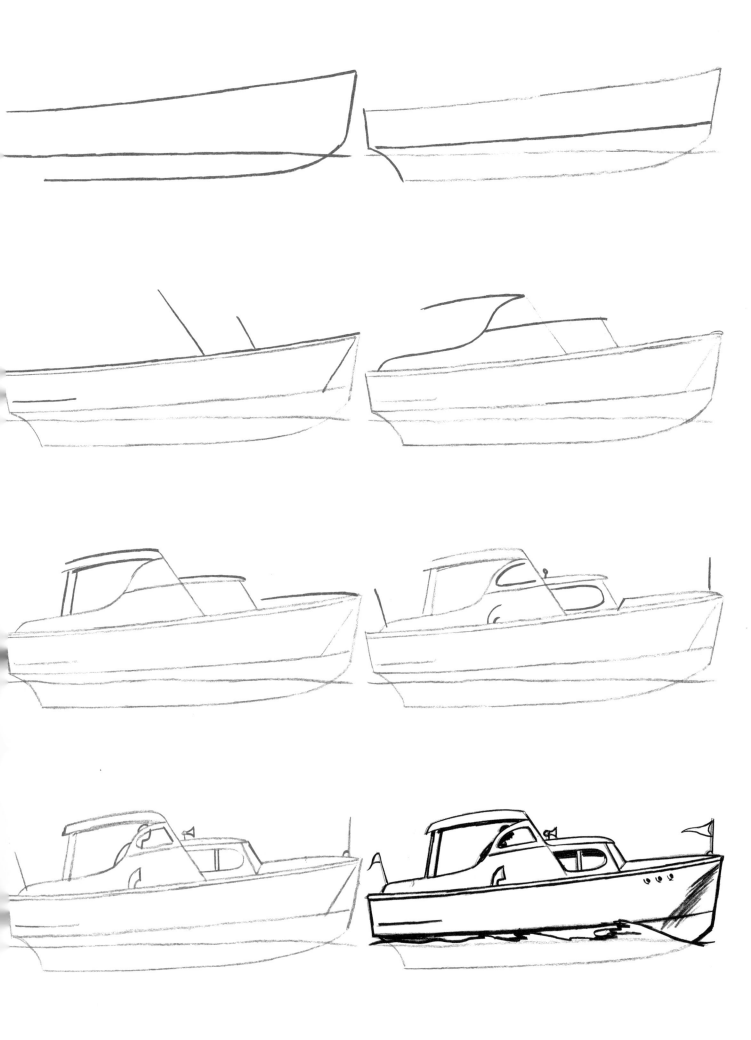

Paddle-wheel houseboat

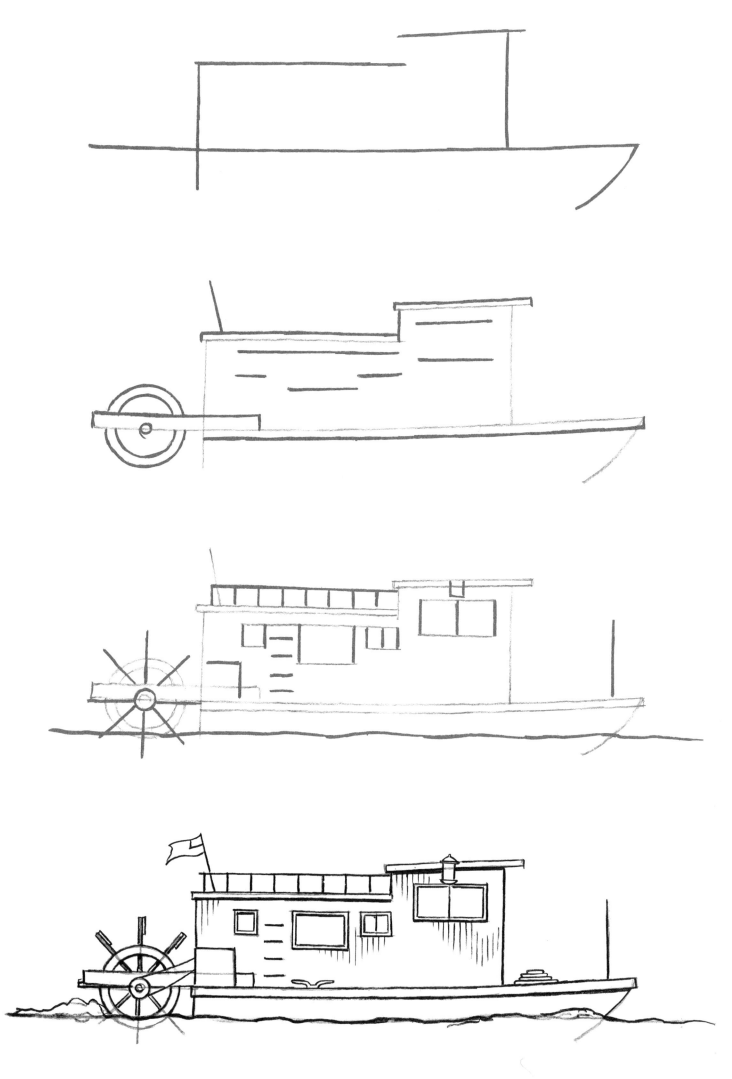

Outboard speedboat

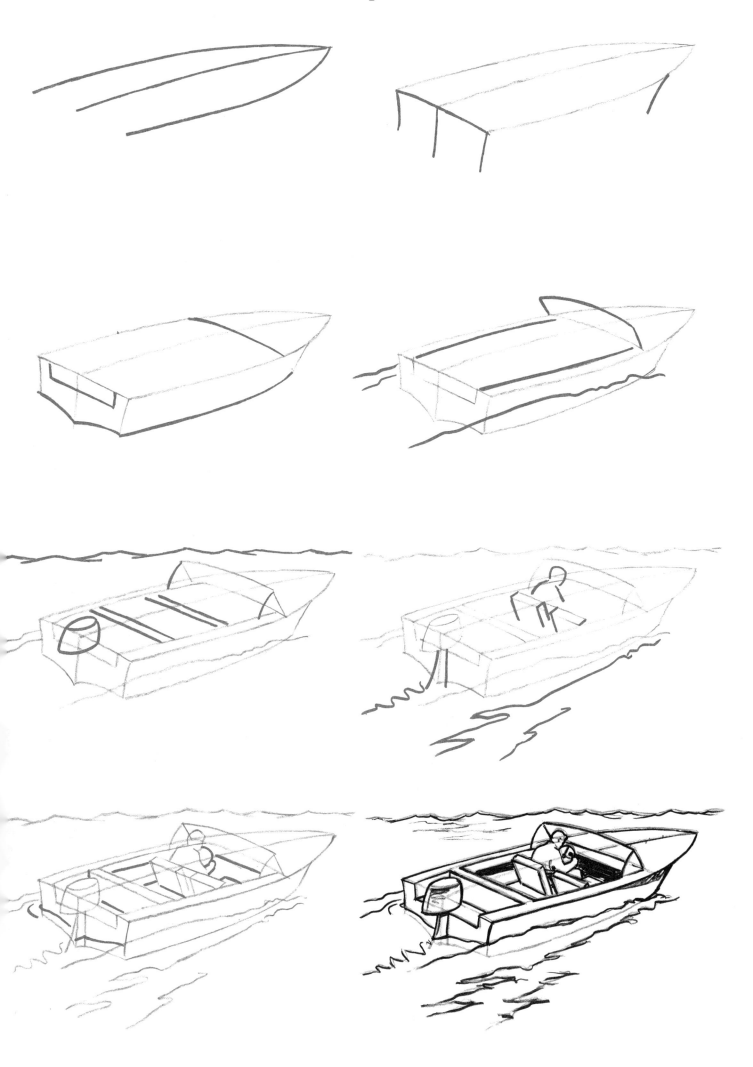

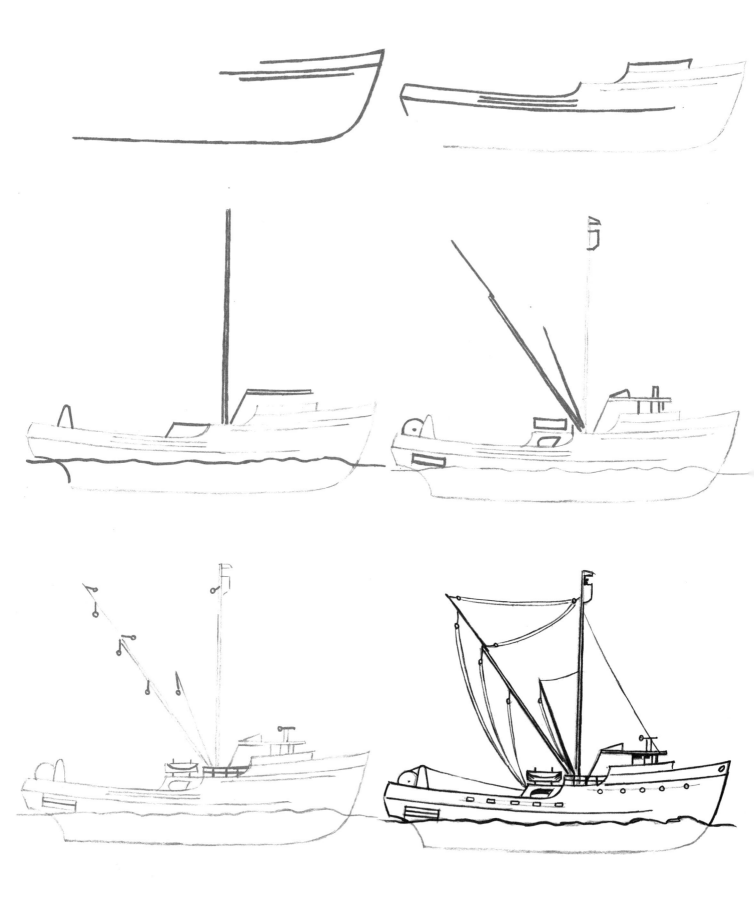

Tugboat

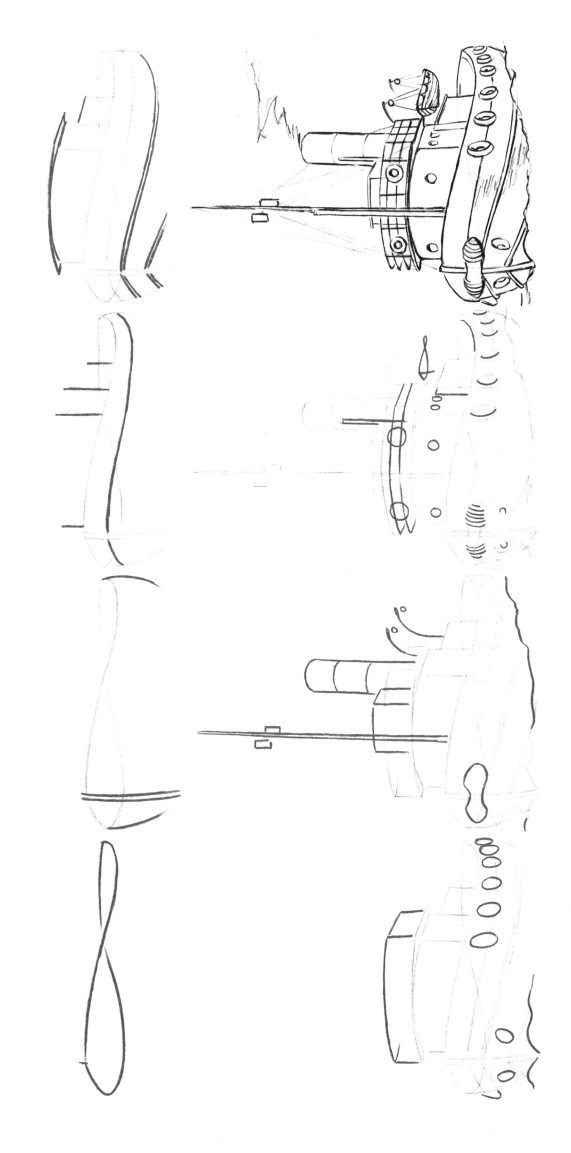

Ocean liner

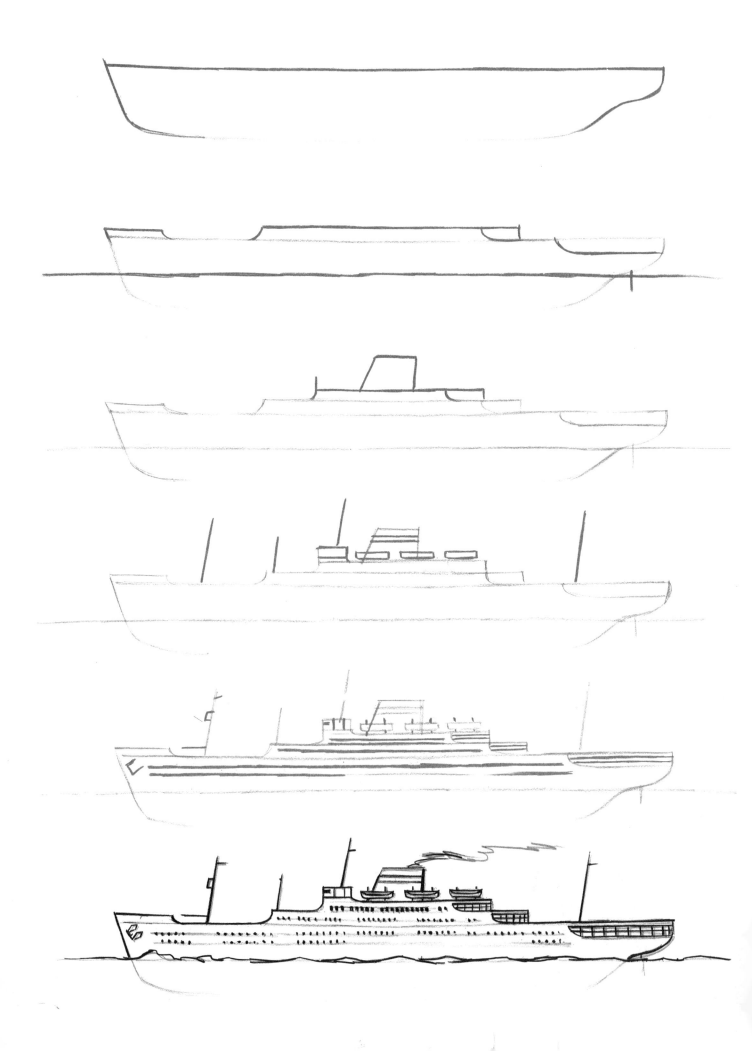

Ocean liner (early twentieth century)

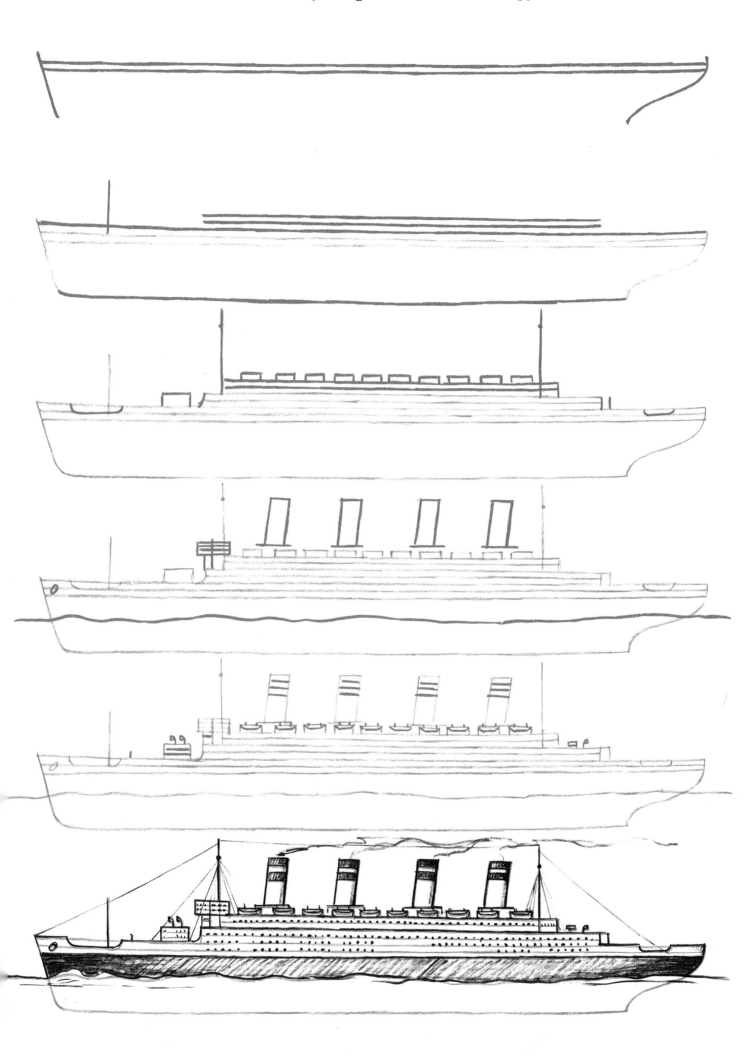

Submarine (U.S.S. Nautilus)

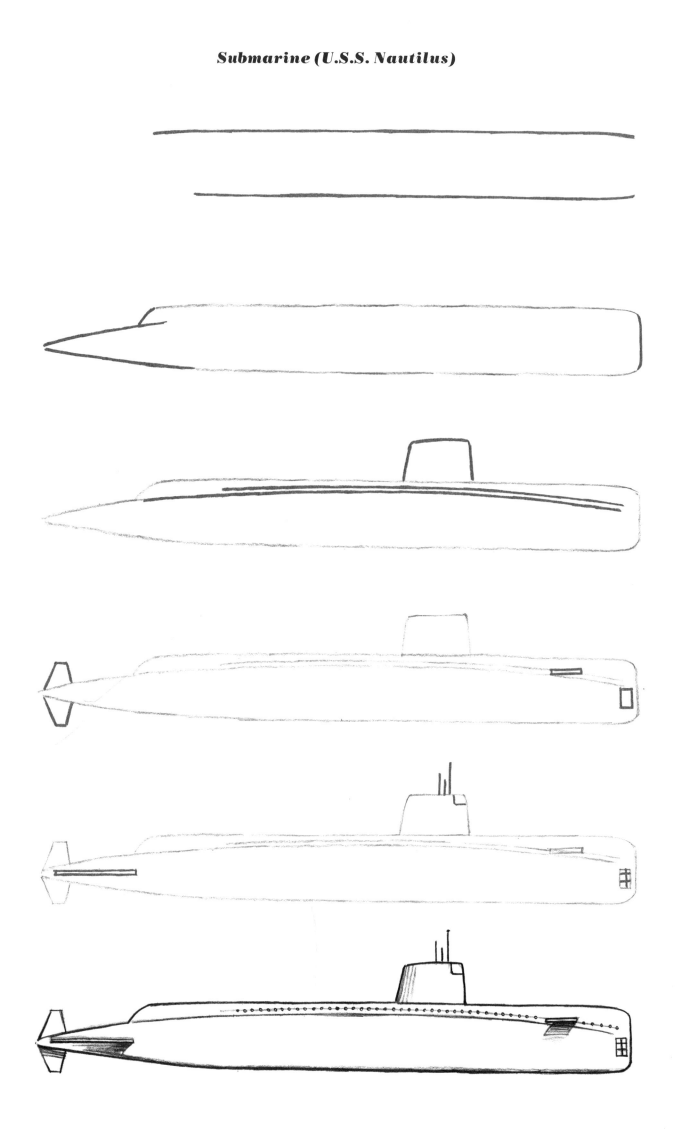

Canoe

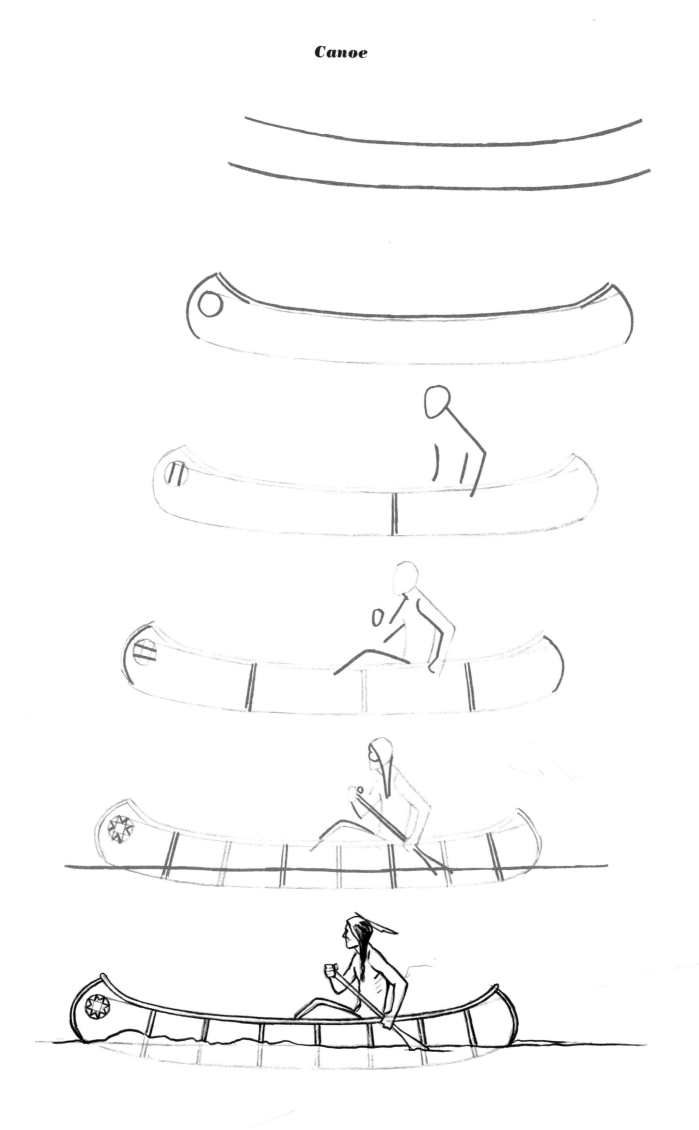

Dory

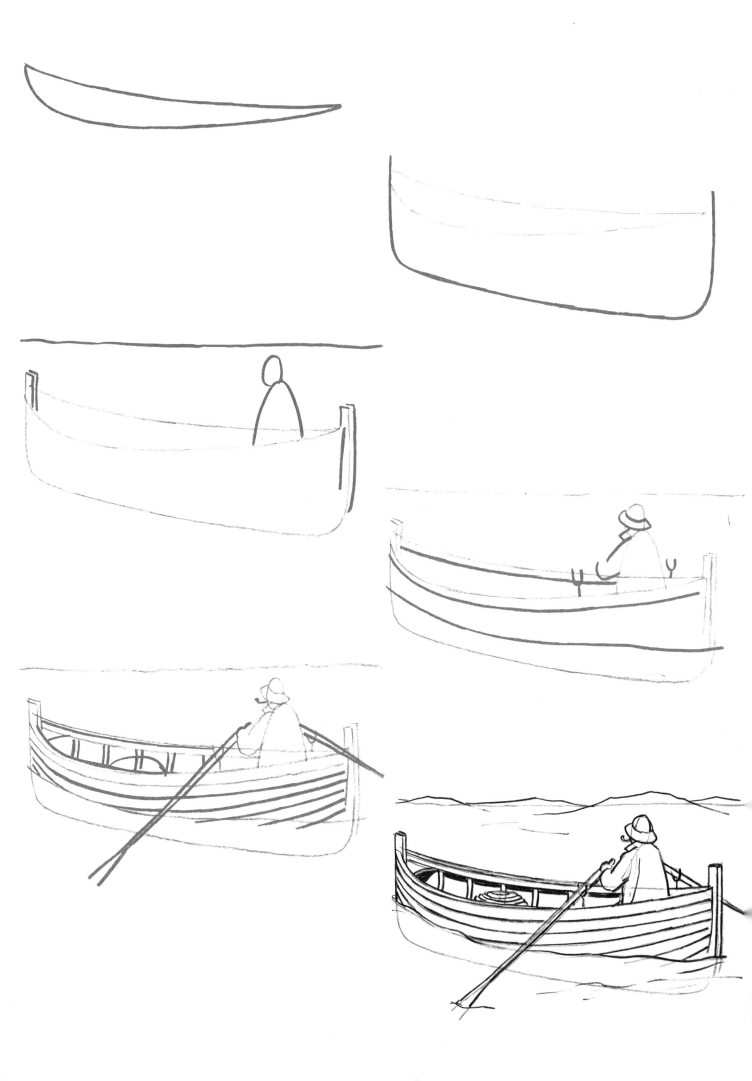

Sloop

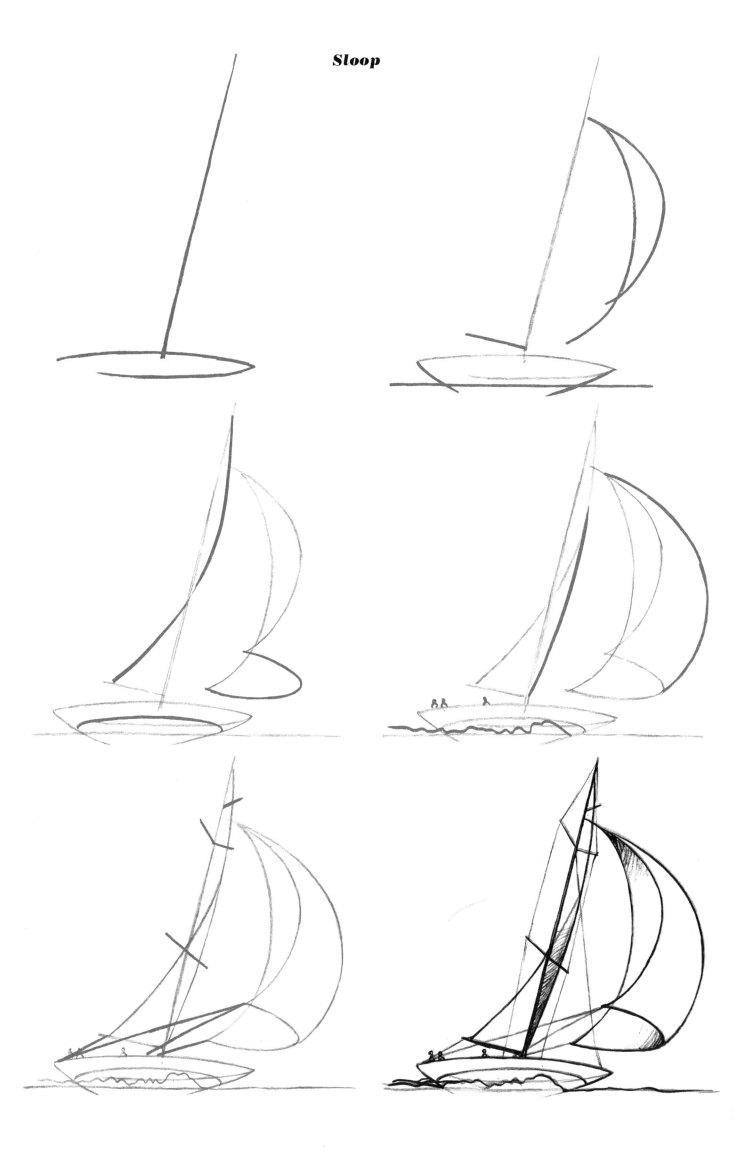

Square-rigged sailing ship

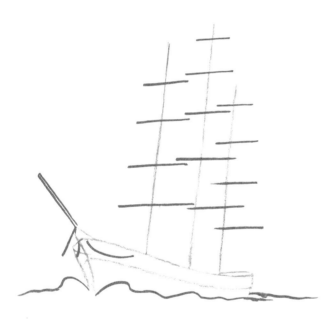

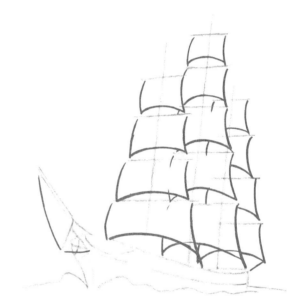

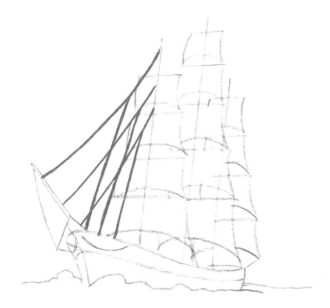

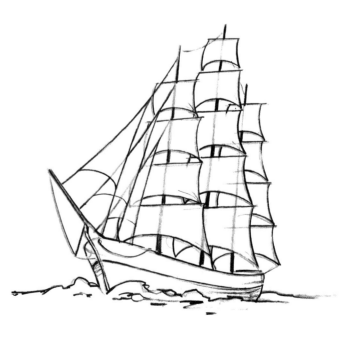

Viking ship

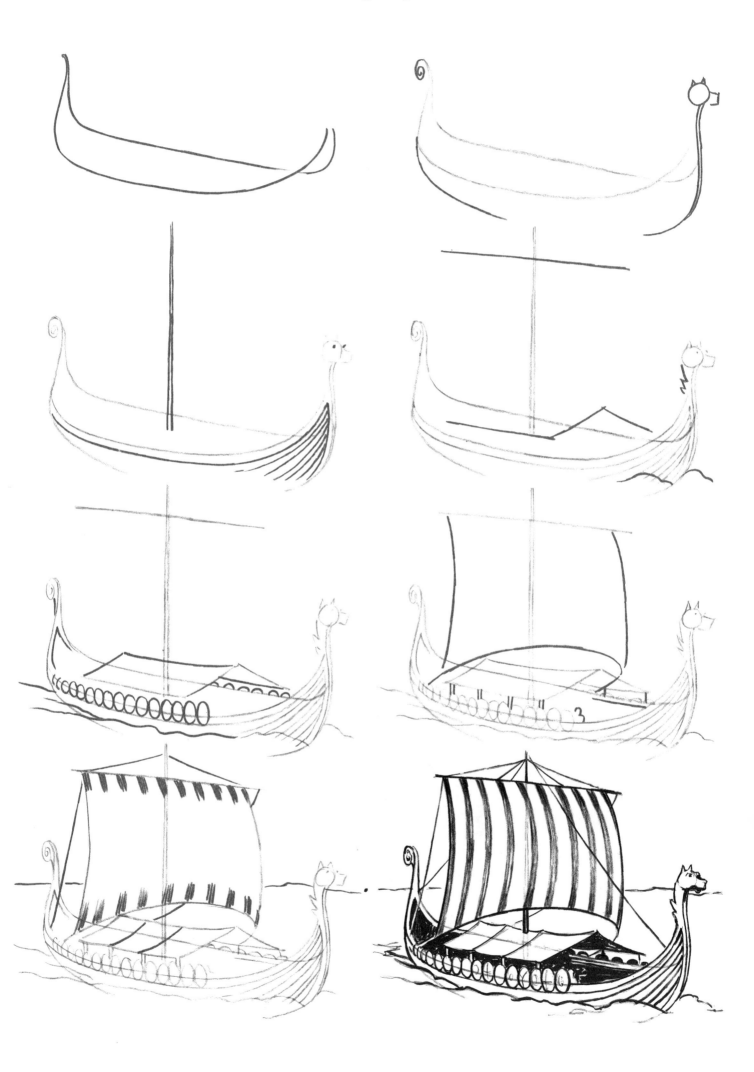

Santa Maria (1492)

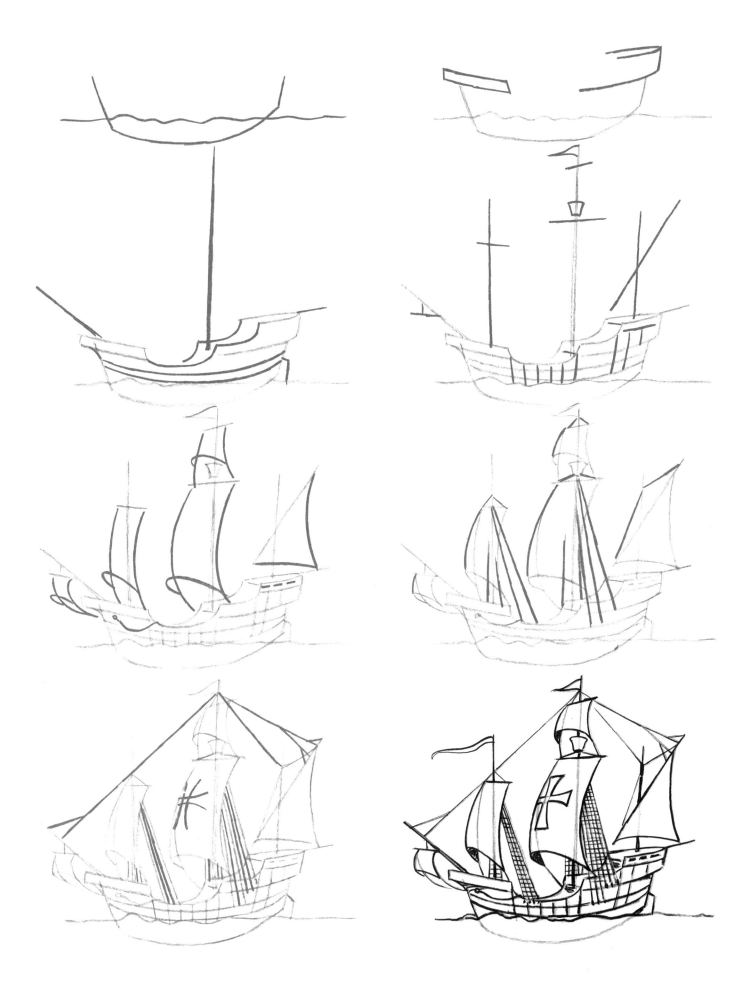

Chinese junk

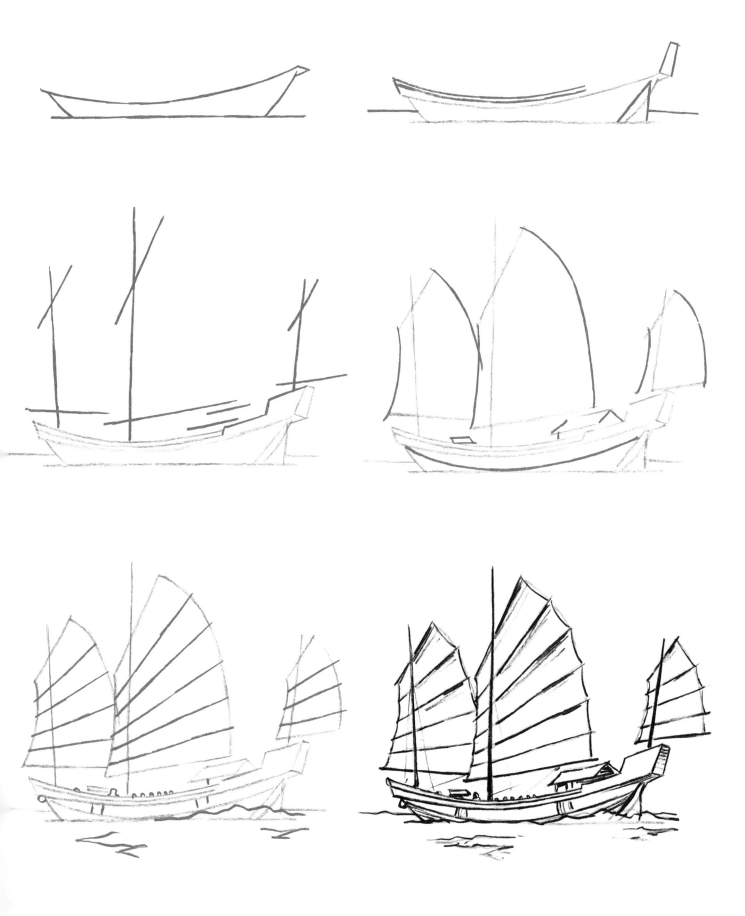

Dump truck

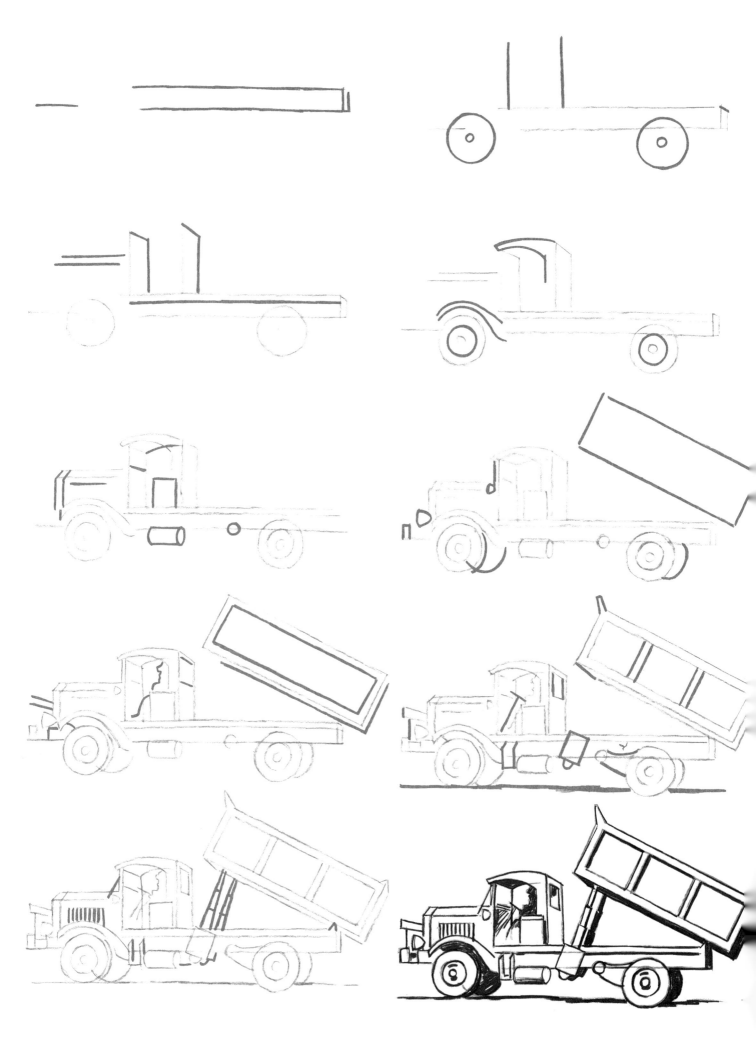

Heavy-duty truck

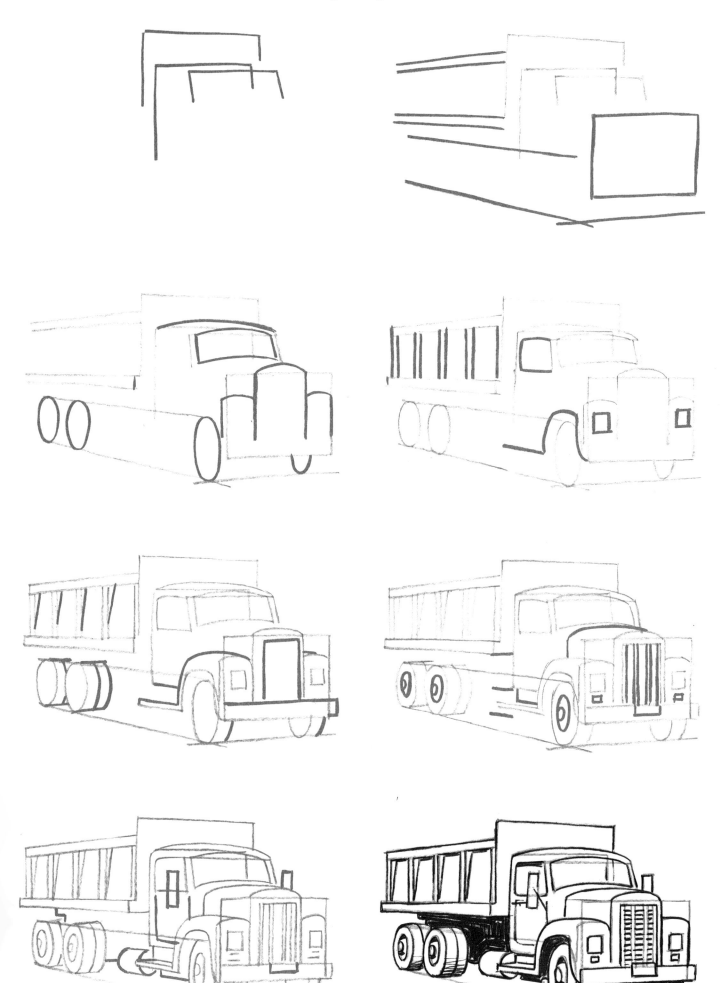

Fire truck

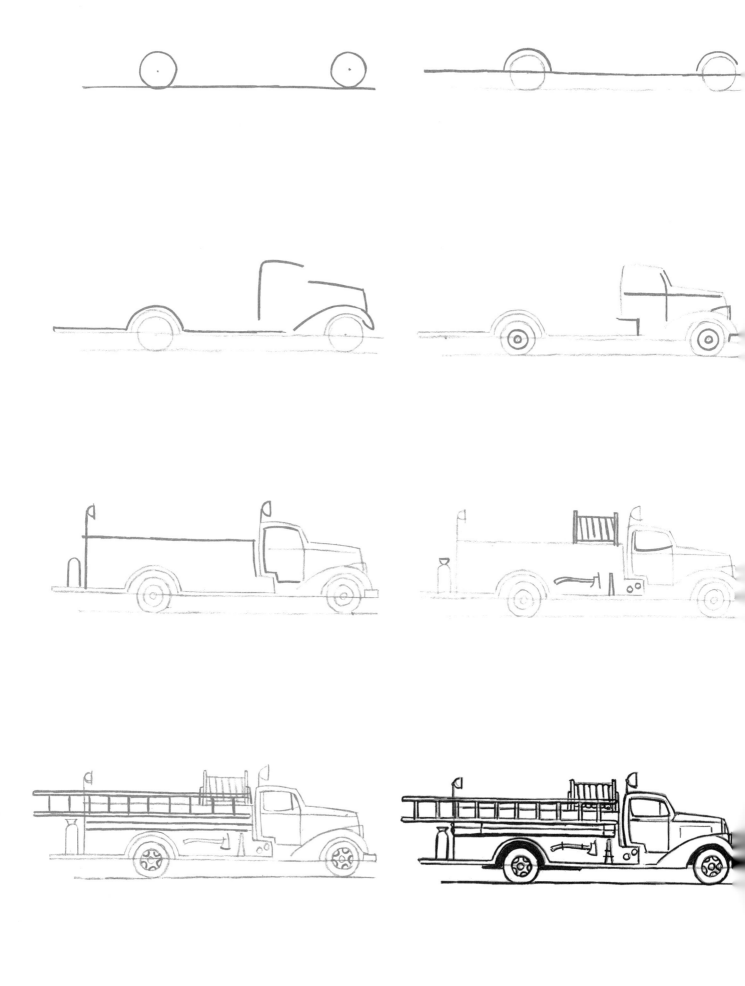

Tank tractor-trailer

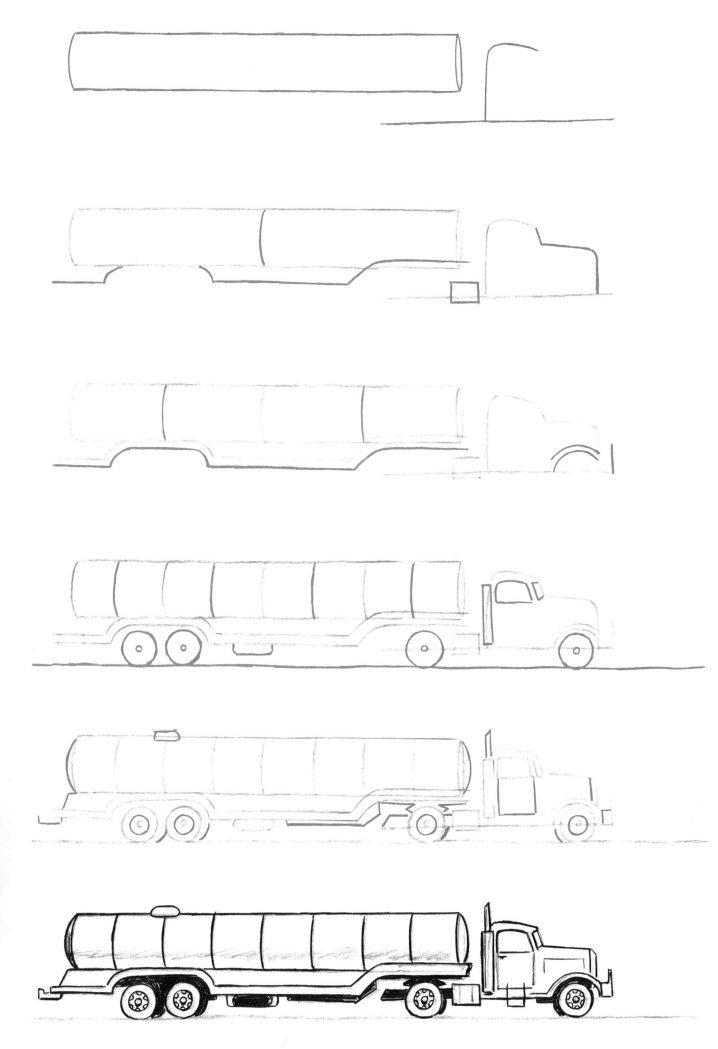

Moving van

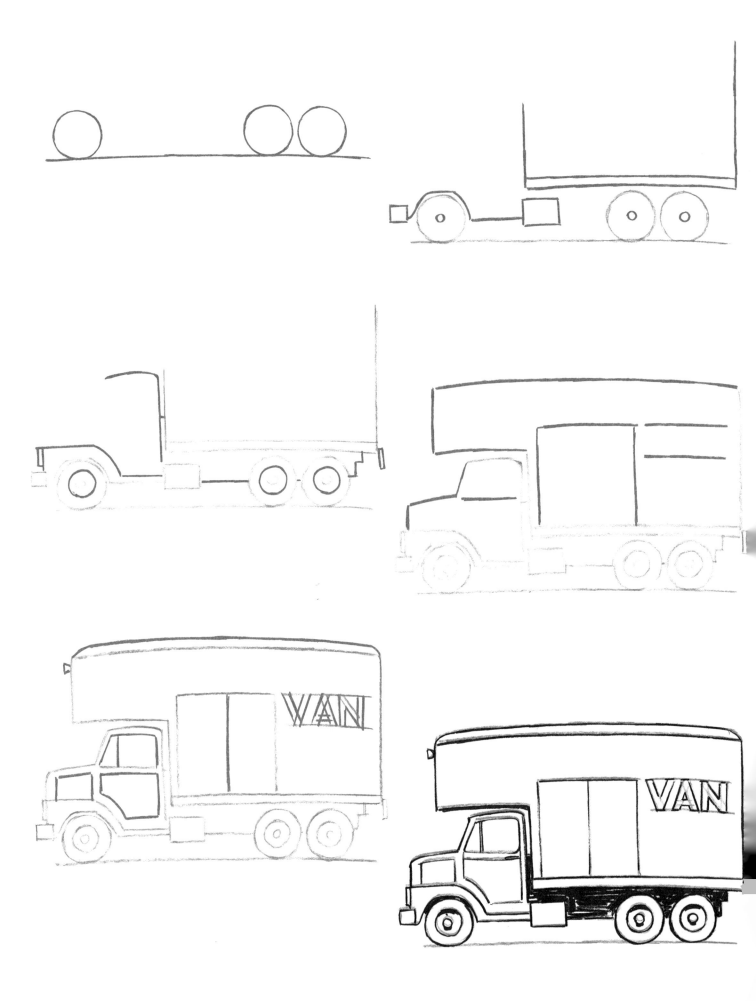

Steam shovel

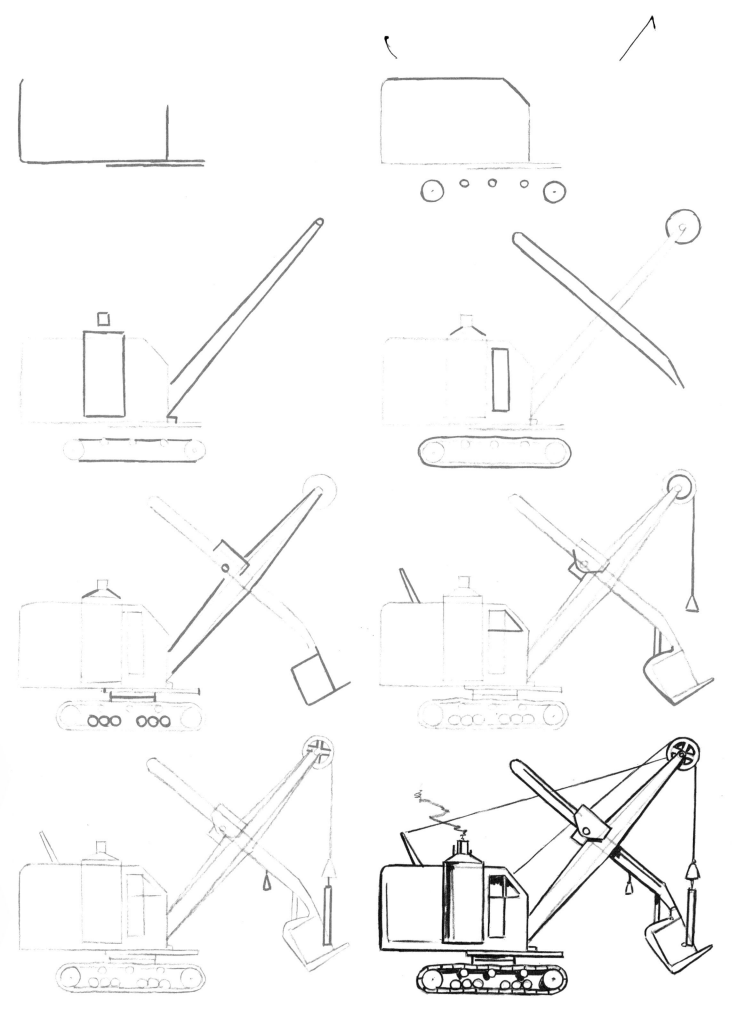

Military tank

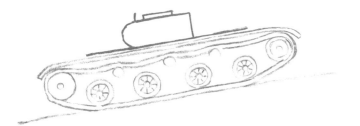

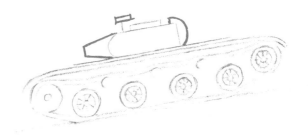

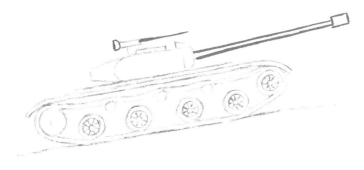

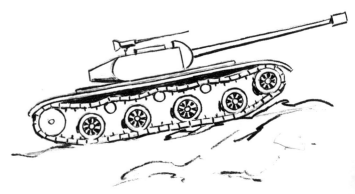

Early steam locomotive

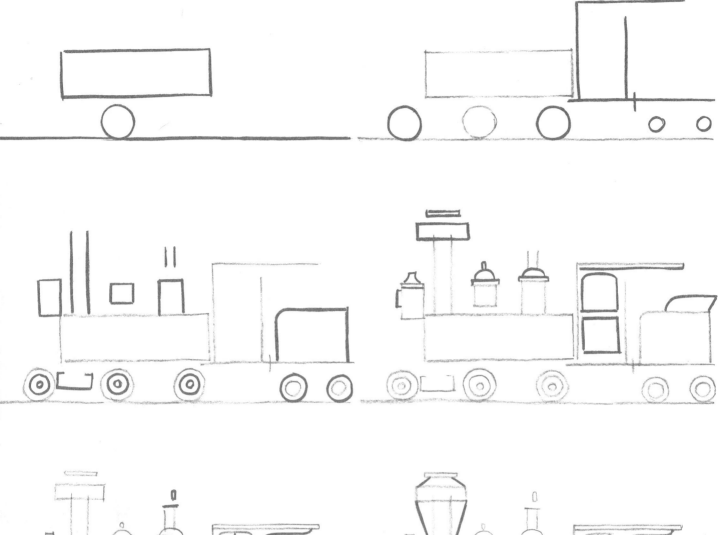

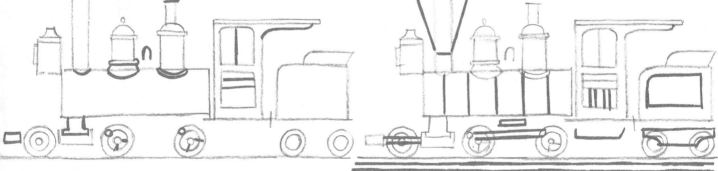

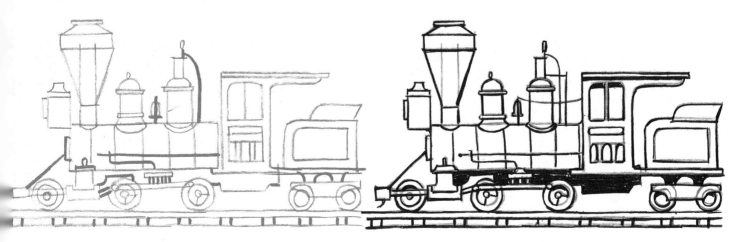

Steam locomotive

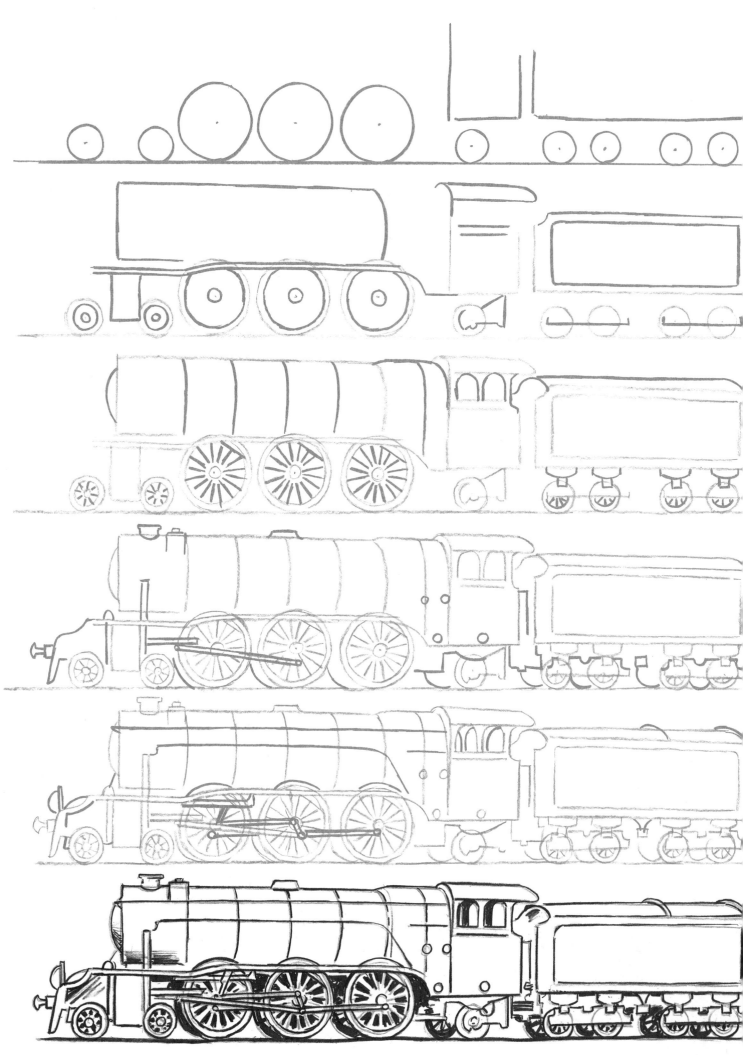

Diesel streamliner

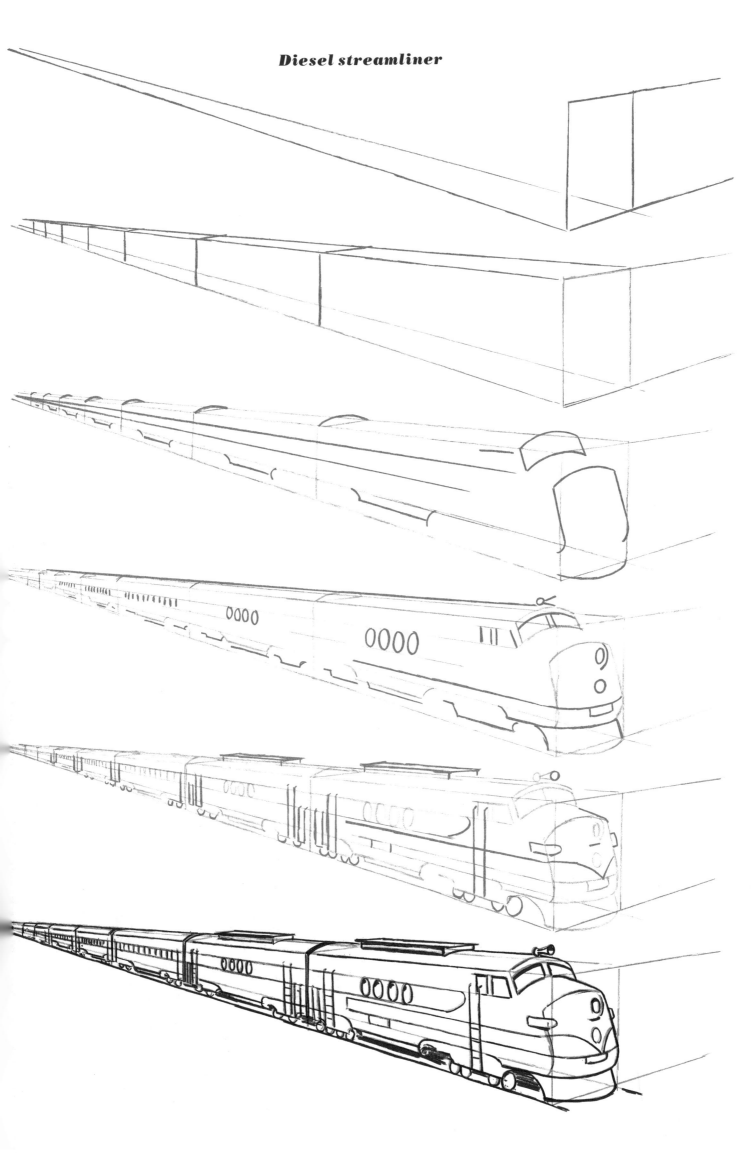

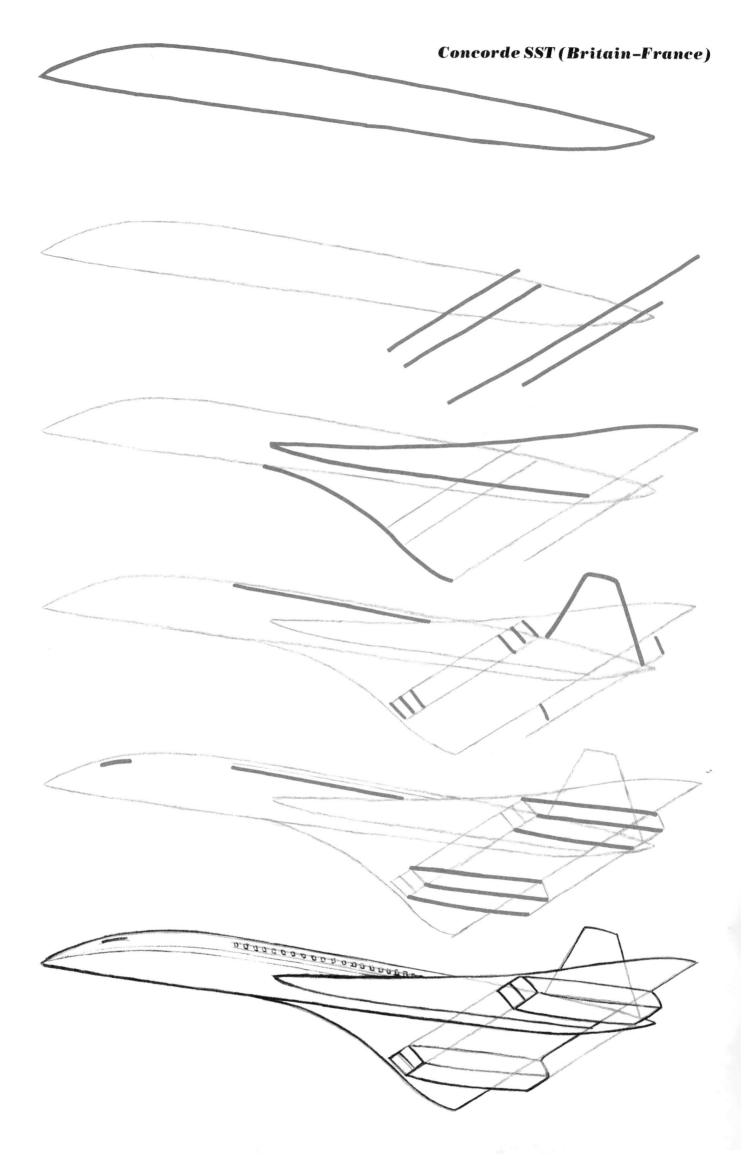

Concorde SST (Britain–France)

Boeing 747 (USA)

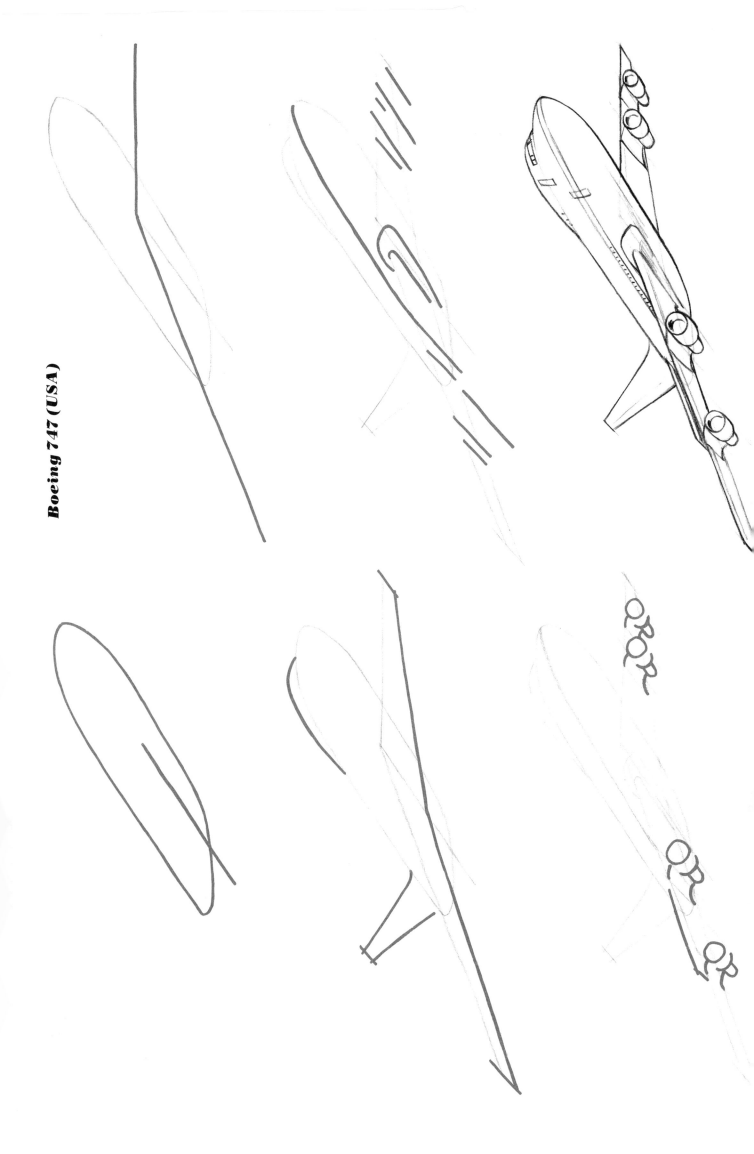

Boeing 727 (USA)

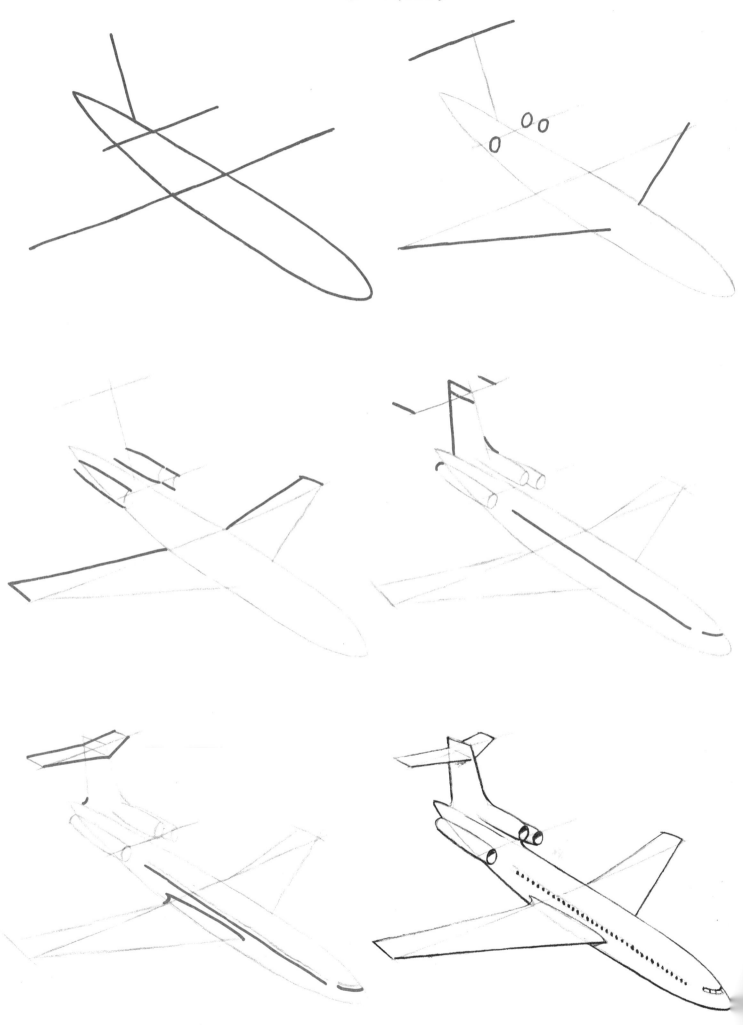

Boeing 707 (USA)

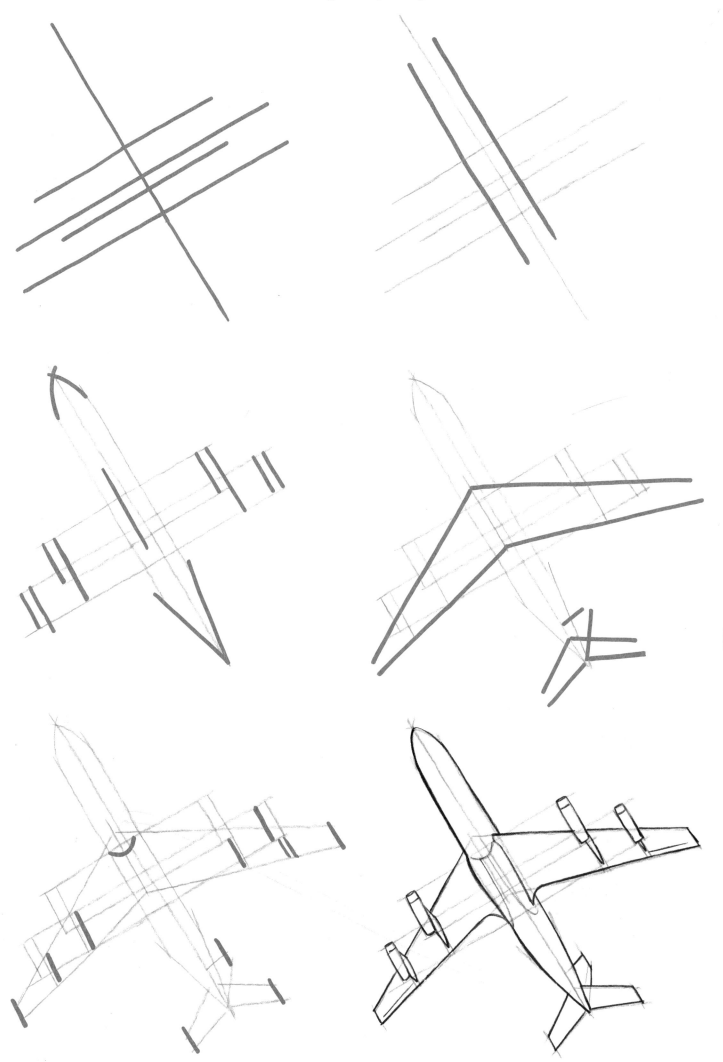

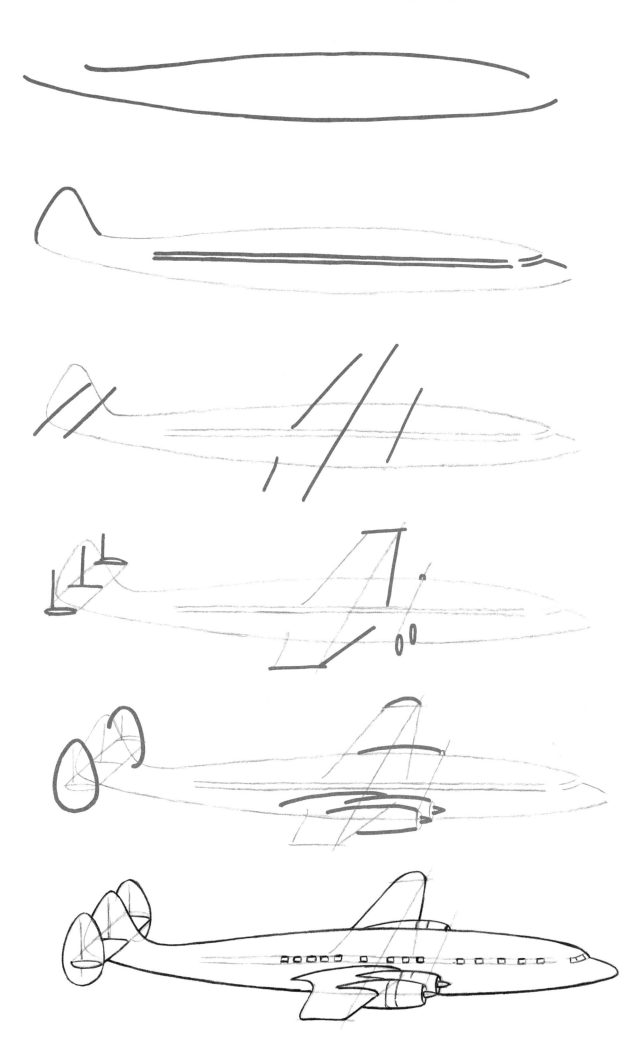

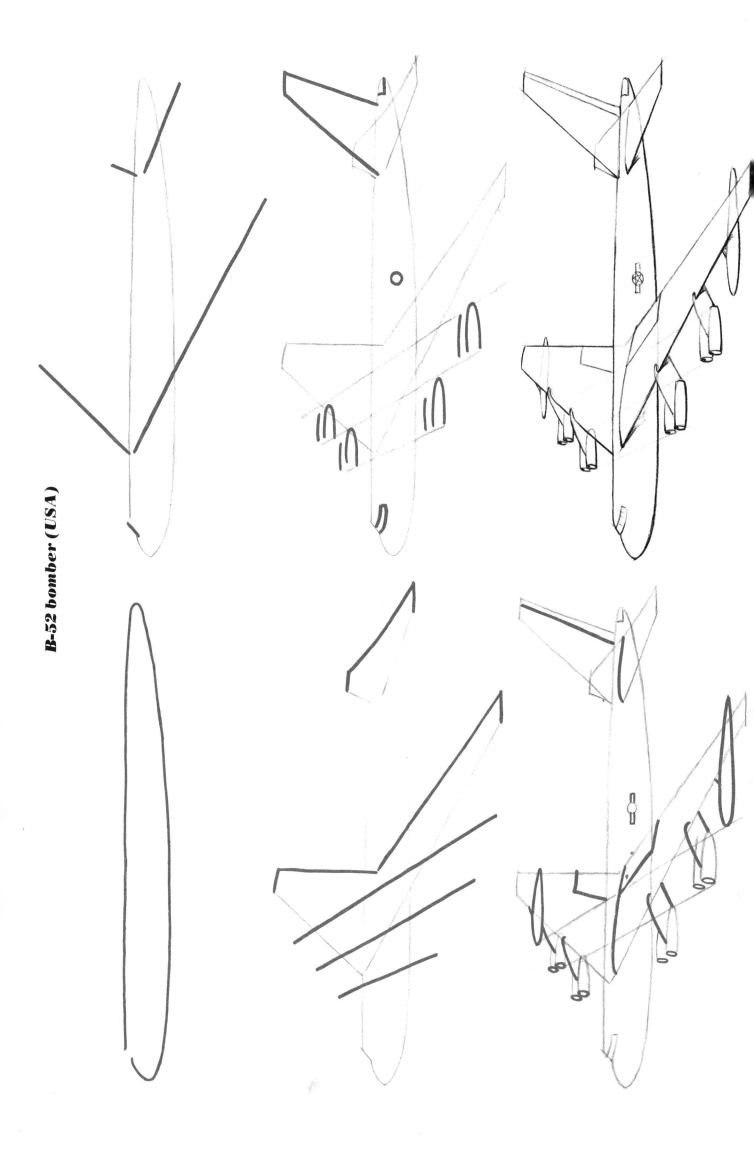

B-52 bomber (USA)

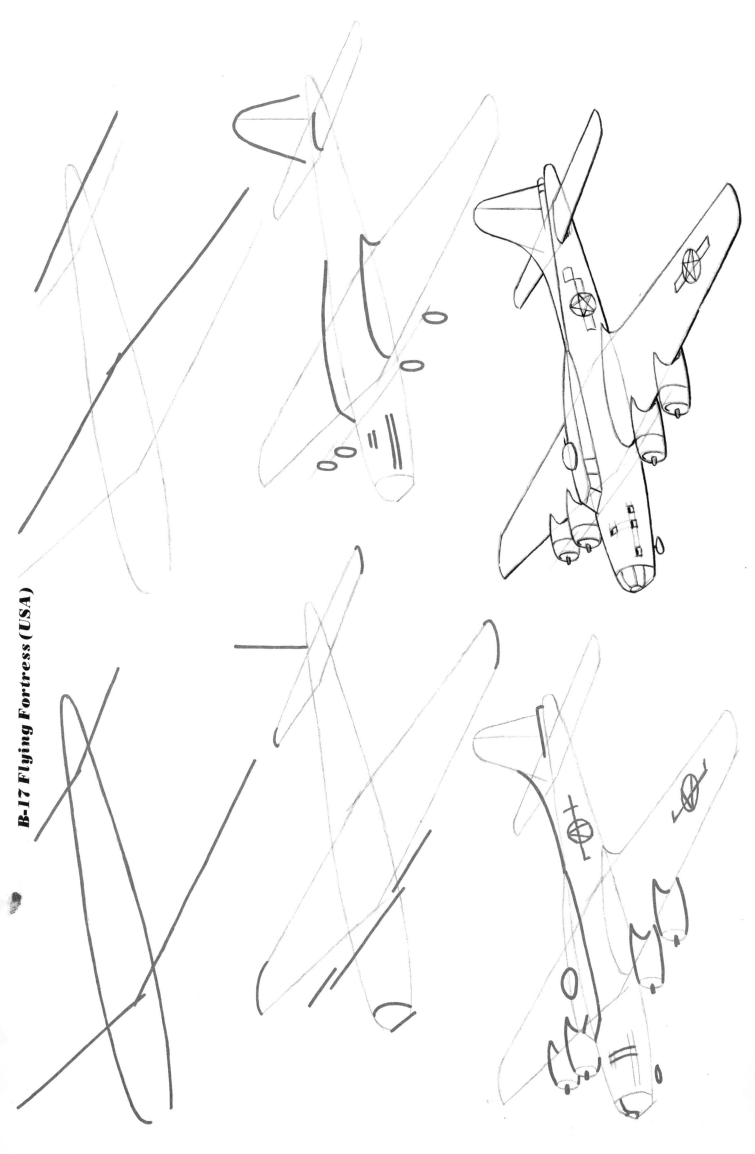

B-17 Flying Fortress (USA)

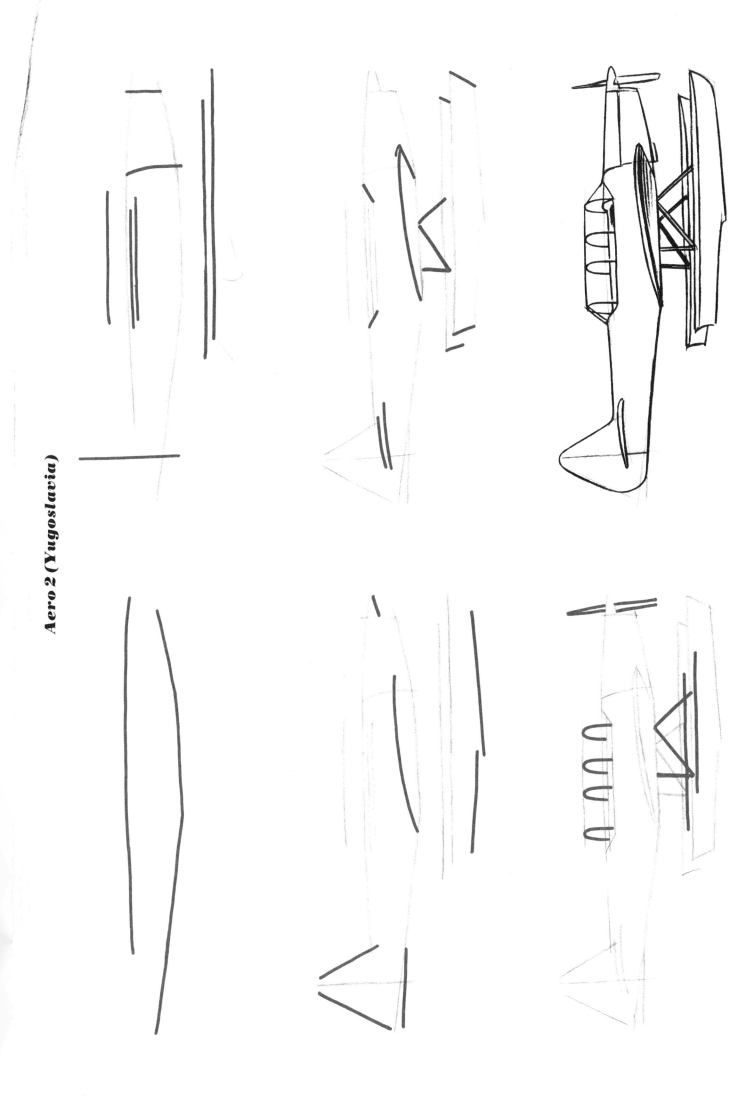

Aero 2 (Yugoslavia)

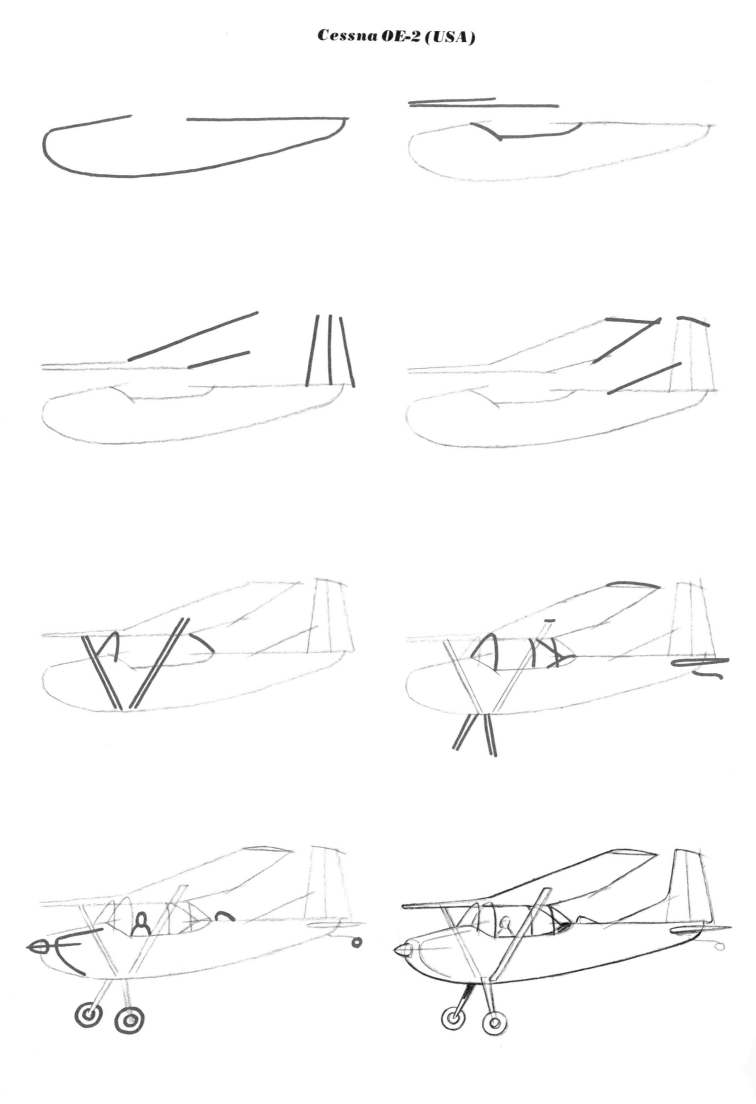

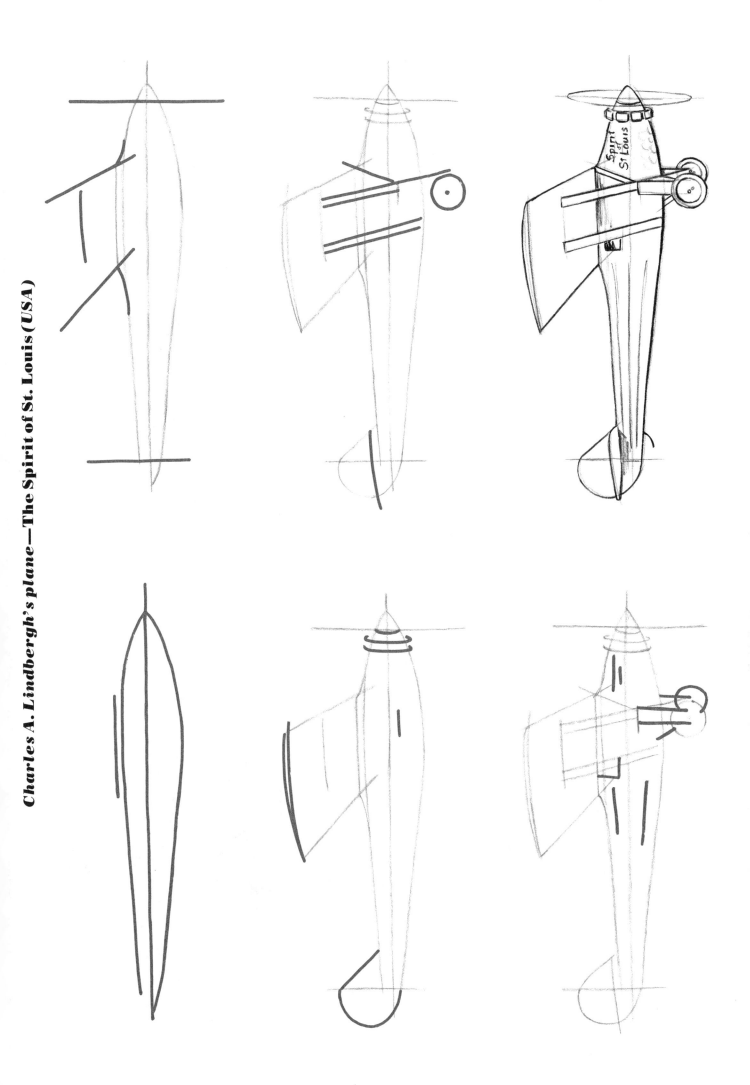

Charles A. Lindbergh's plane—The Spirit of St. Louis (USA)

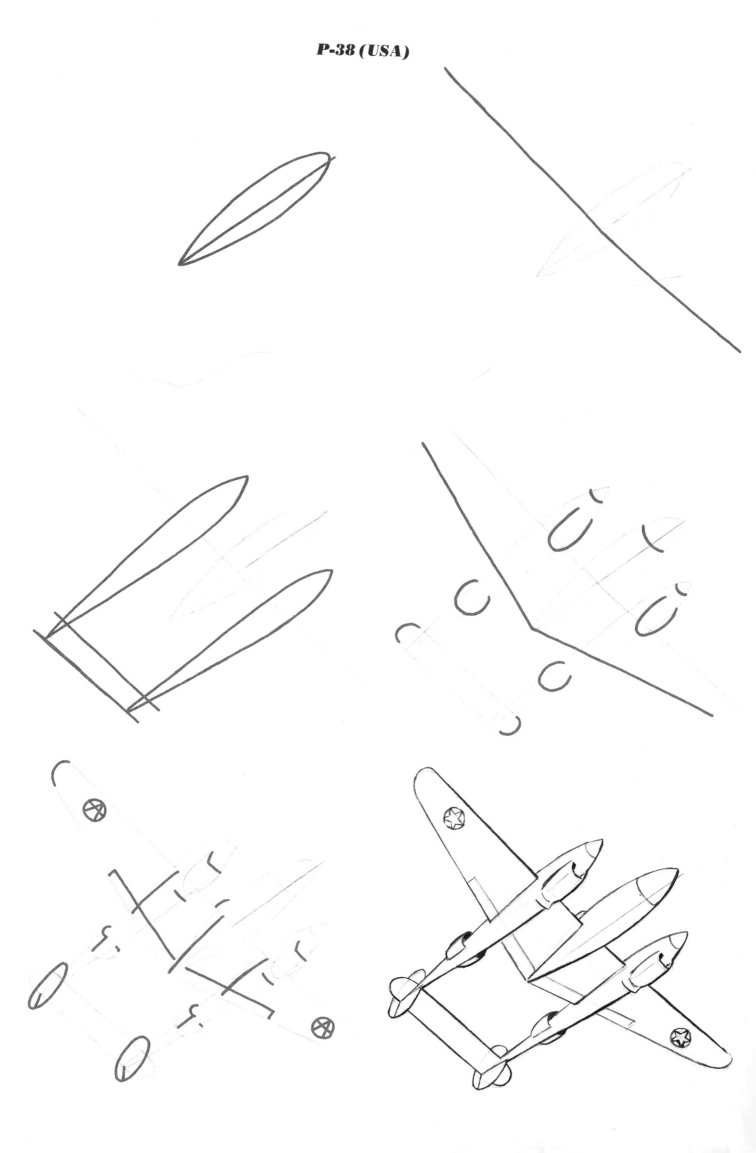

P-40 (USA)

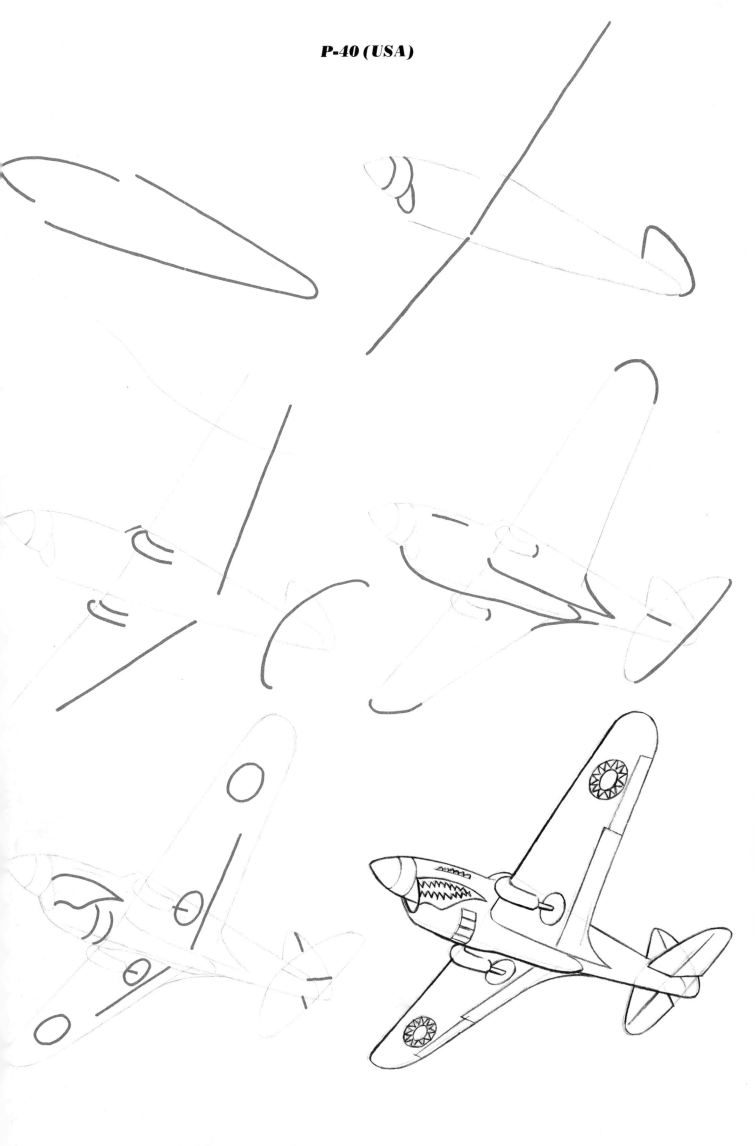

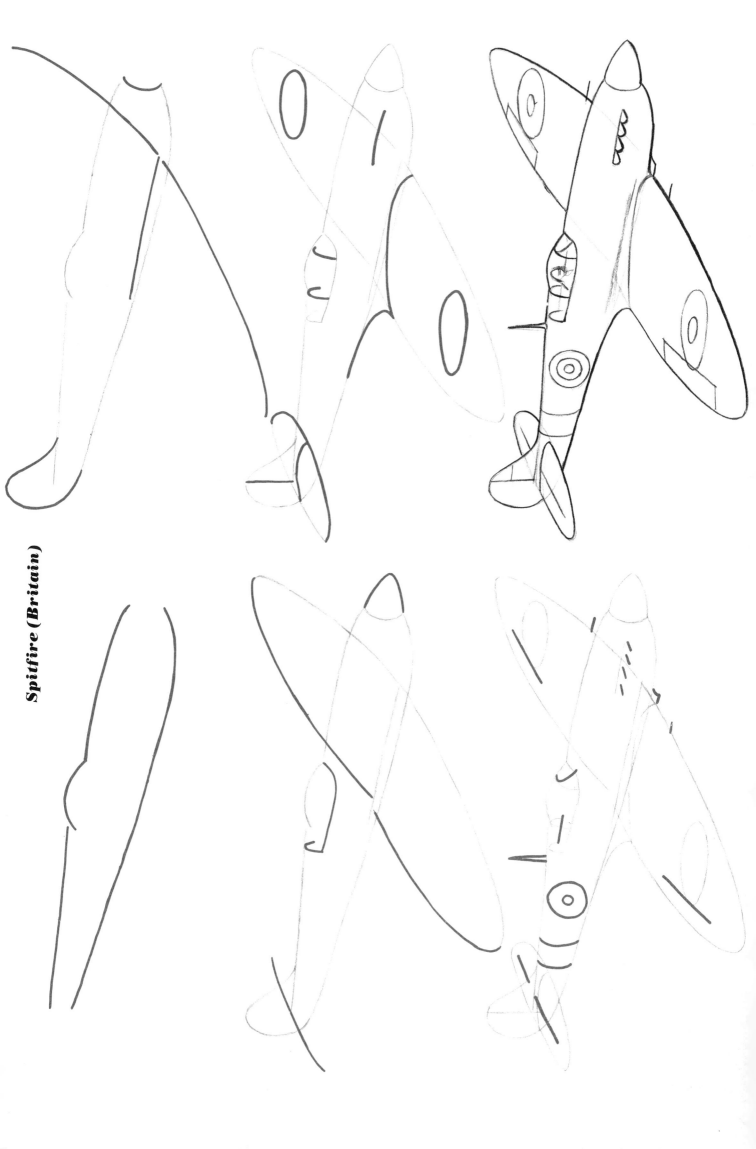

Spitfire (Britain)

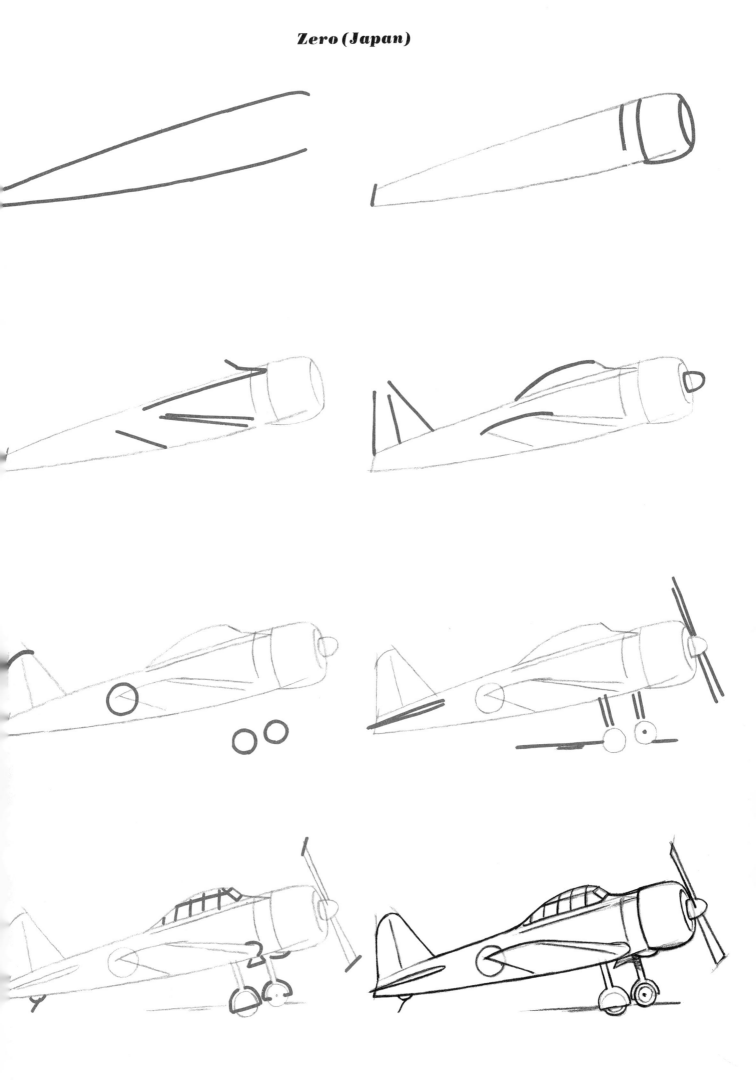

Sopwith Snipe (Britain)

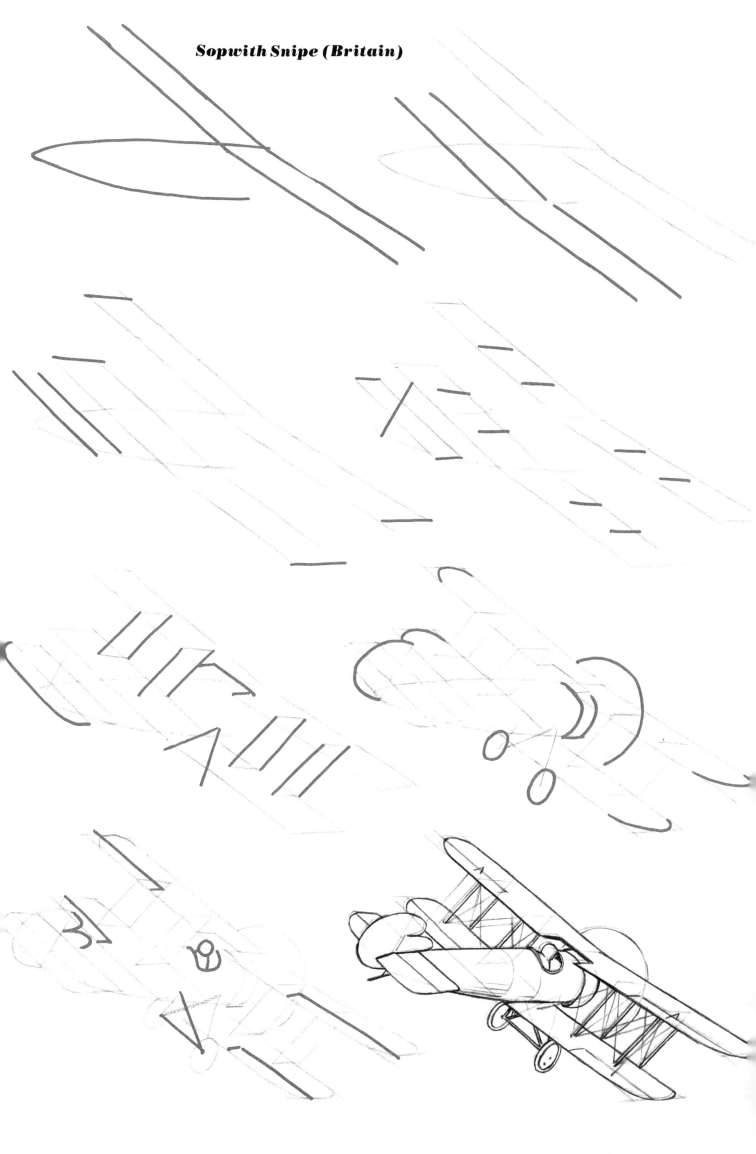

Spad (France)

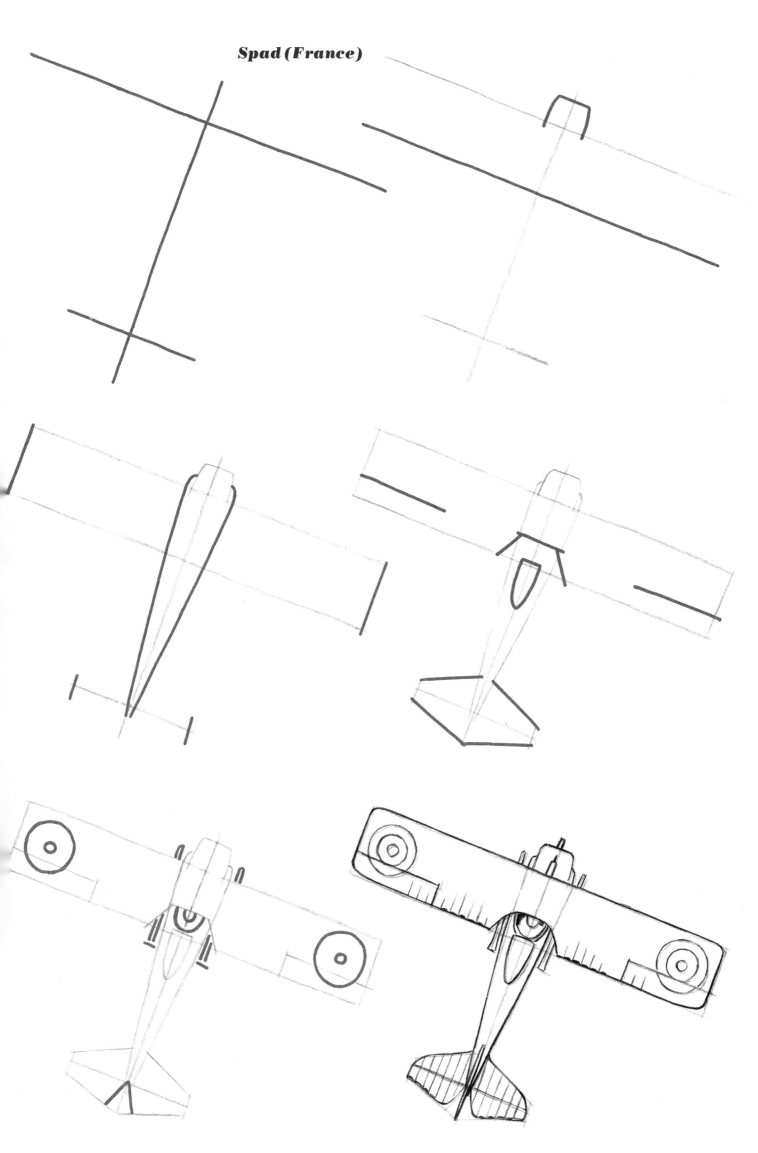

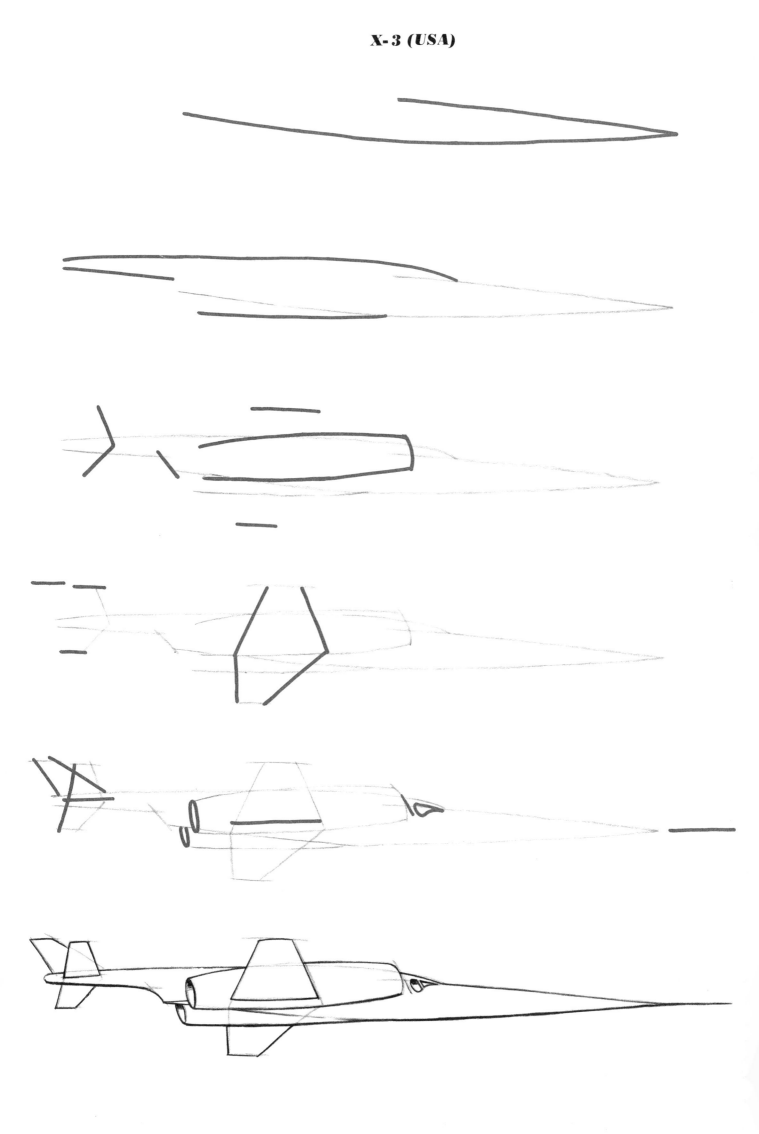

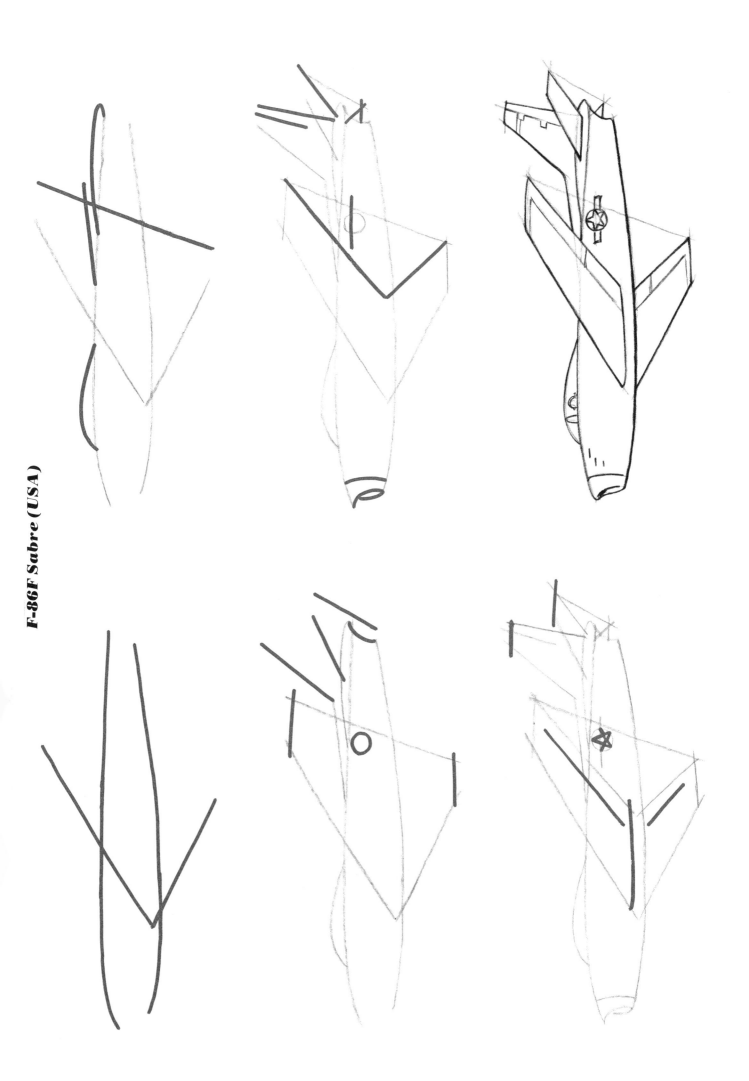

F-86F Sabre (USA)

Lockheed F-94C Starfire (USA)

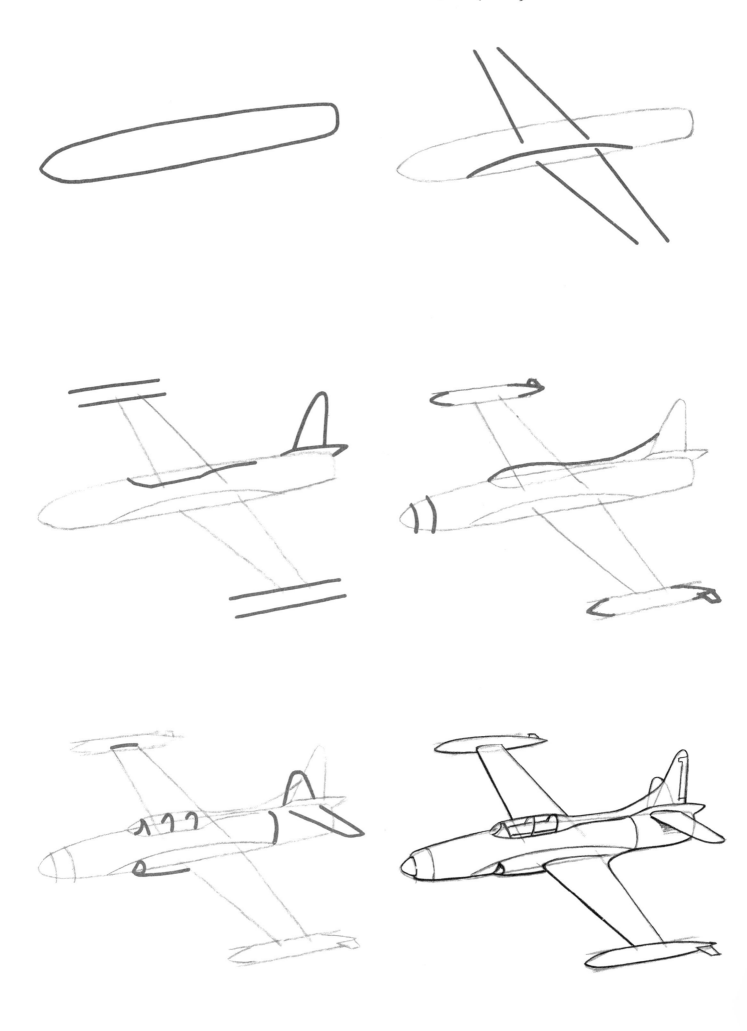

Helicopter

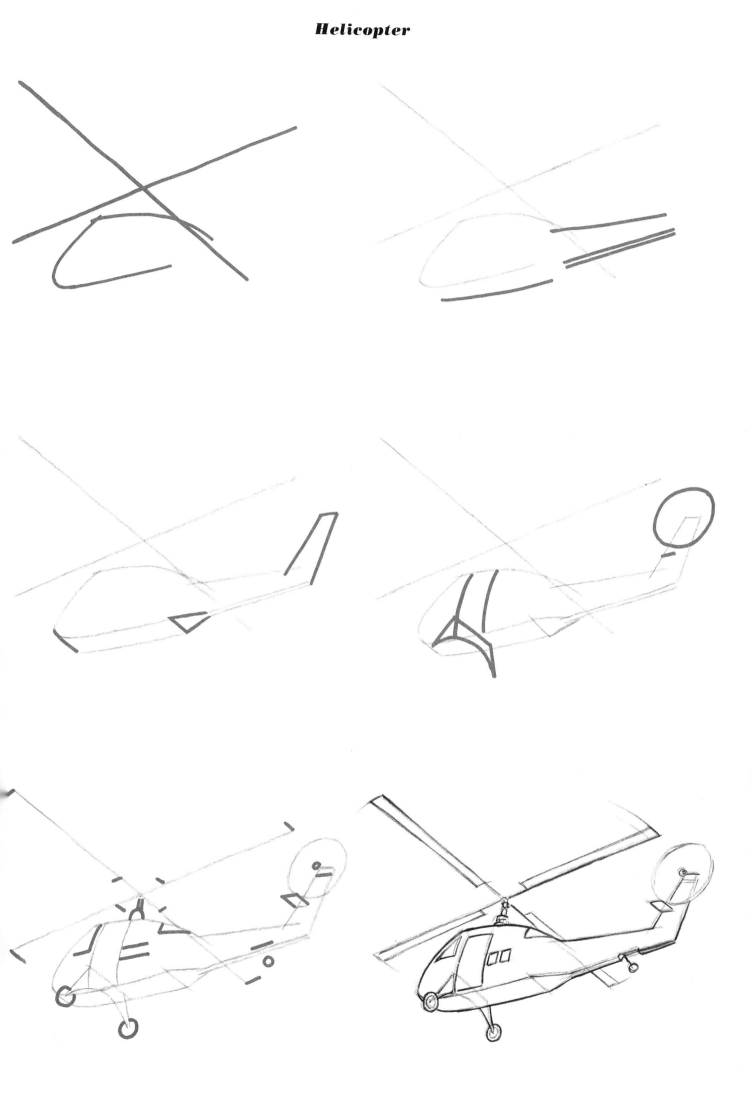

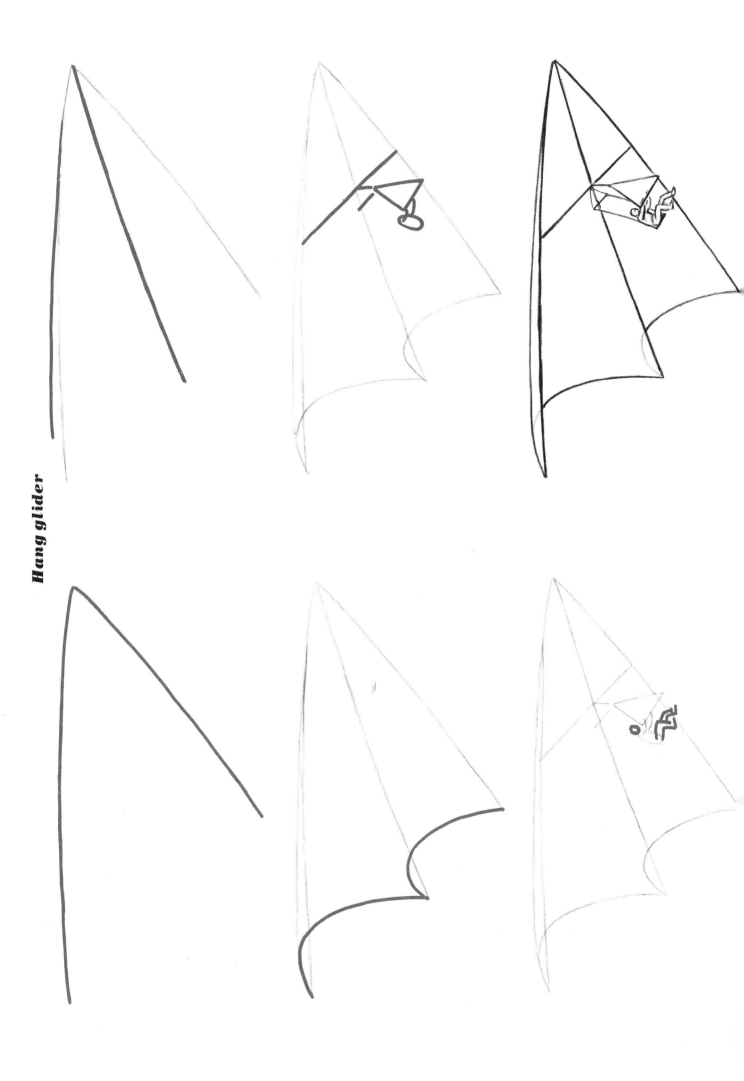

Hang glider

Apollo command module (USA)

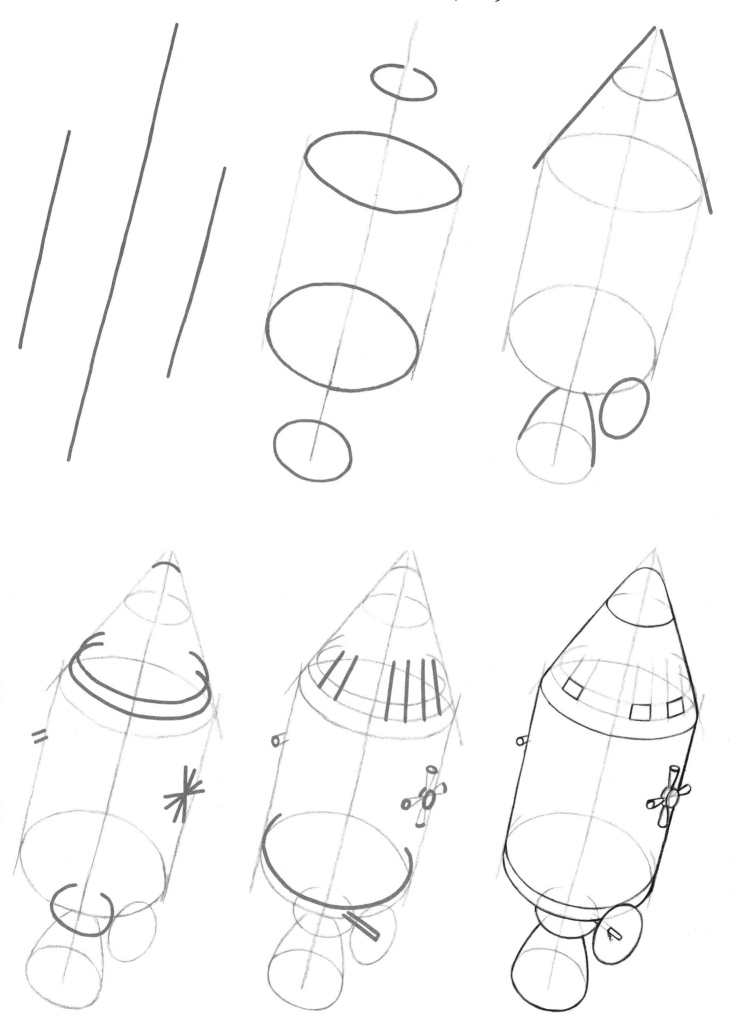

Gemini capsule (USA)

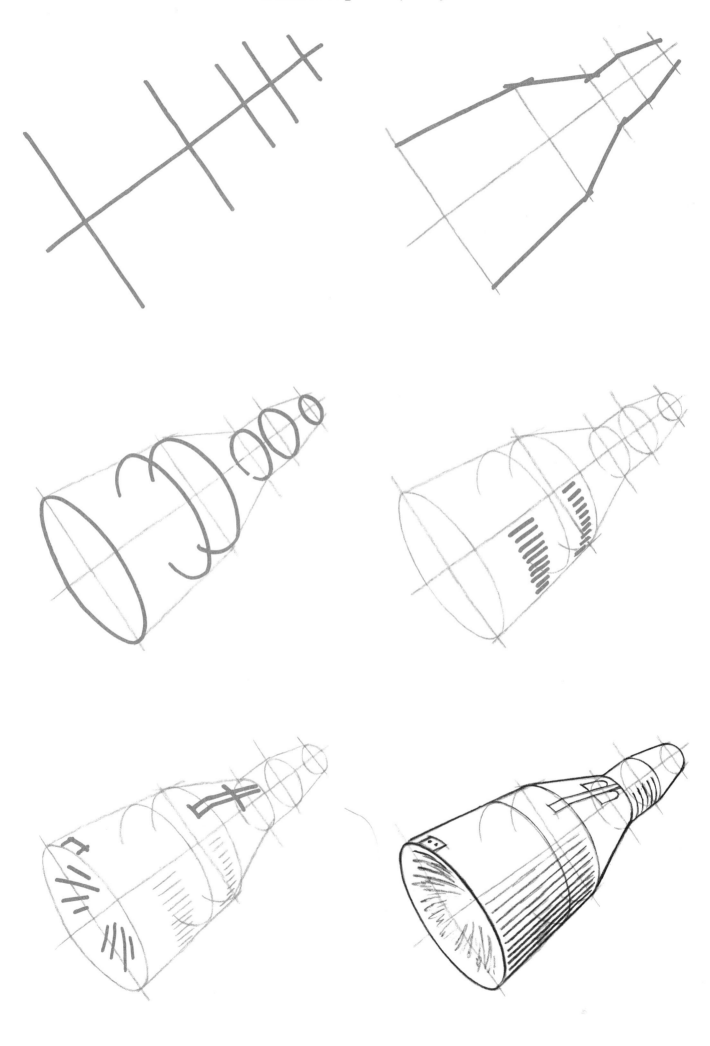

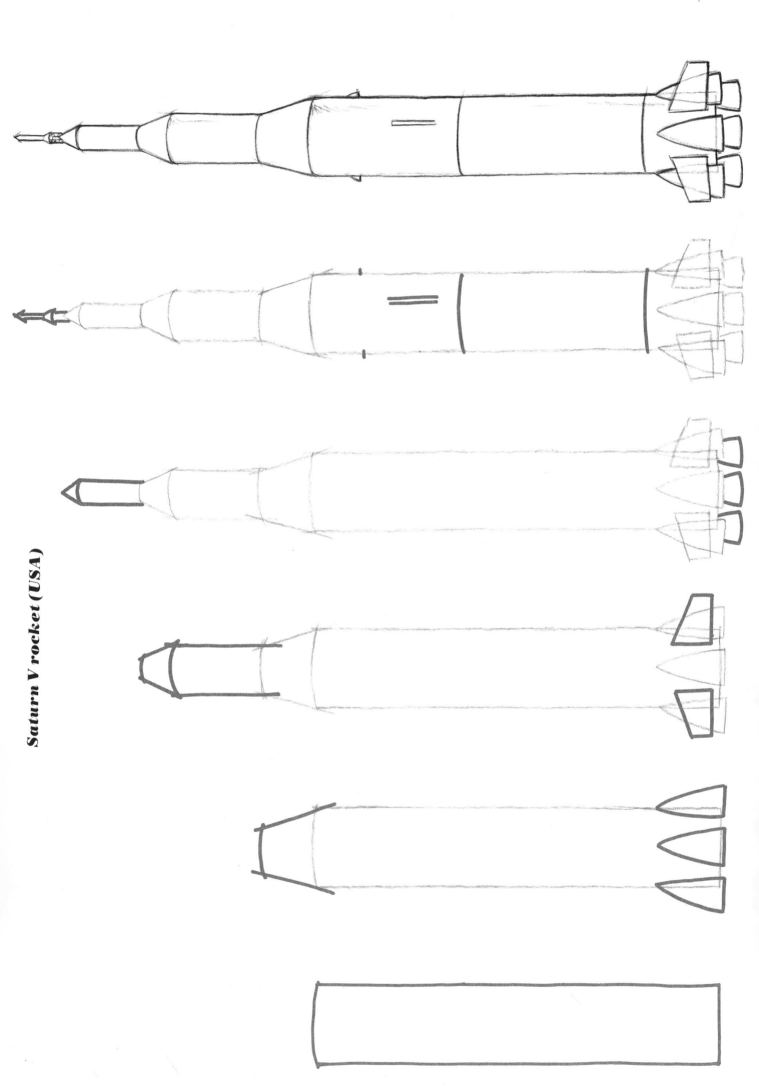

Saturn V rocket (USA)

The Wright brothers' first airplane

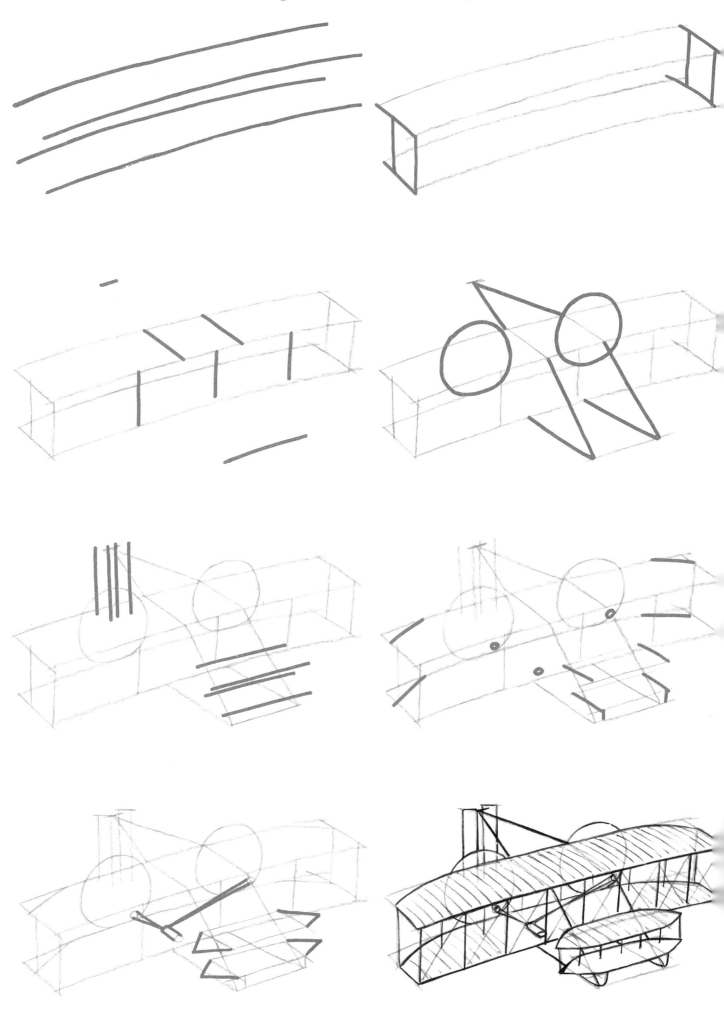

Lee J. Ames has been "drawing 50" since 1974, when the first "Draw 50" title—*Draw 50 Animals*—was published. Since that time, Ames has taught millions of people to draw everything from dinosaurs and sharks to boats, buildings and cars. There are currently twenty titles in the "Draw 50" series, with nearly two million books sold.

DRAW 50 FOR HOURS OF FUN!

*Using Lee J. Ames's proven, step-by-step method of drawing instruction you can easily
learn to draw animals, monsters, airplanes, cars, sharks, buildings, dinosaurs, famous cartoons, and so much
more! Millions of people have learned to draw by using the award-winning
"Draw 50" technique. Now you can too!*

COLLECT THE ENTIRE DRAW 50 SERIES!

*The Draw 50 Series books are available from your local bookstore.
You may also order direct (make a copy of this form to order).*

Titles are paperback, unless otherwise indicated.

ISBN	TITLE	PRICE	QTY	TOTAL
23629-8	Airplanes, Aircraft, and Spacecraft	$8.95/$11.95 Can	X ___ = ___	
19519-2	Animals	$8.95/$11.95 Can	X ___ = ___	
24638-2	Athletes	$8.95/$11.95 Can	X ___ = ___	
26767-3	Beasties and Yugglies and Turnover Uglies and Things That Go Bump in the Night	$8.95/$11.95 Can	X ___ = ___	
23630-1	Boats, Ships, Trucks and Trains	$8.95/$11.95 Can	X ___ = ___	
41777-2	Buildings and Other Structures	$8.95/$11.95 Can	X ___ = ___	
24639-0	Cars, Trucks, and Motorcycles	$8.95/$11.95 Can	X ___ = ___	
24640-4	Cats	$8.95/$11.95 Can	X ___ = ___	
42449-3	Creepy Crawlies	$8.95/$11.95 Can	X ___ = ___	
19520-6	Dinosaurs and Other Prehistoric Animals	$8.95/$11.95 Can	X ___ = ___	
23431-7	Dogs	$8.95/$11.95 Can	X ___ = ___	
46985-3	Endangered Animals	$8.95/$11.95 Can	X ___ = ___	
19521-4	Famous Cartoons	$8.95/$11.95 Can	X ___ = ___	
23432-5	Famous Faces	$8.95/$11.95 Can	X ___ = ___	
47150-5	Flowers, Trees, and Other Plants	$8.95/$11.95 Can	X ___ = ___	
26770-3	Holiday Decorations	$8.95/$11.95 Can	X ___ = ___	
17642-2	Horses	$8.95/$11.95 Can	X ___ = ___	
17639-2	Monsters	$8.95/$11.95 Can	X ___ = ___	
41194-4	People	$8.95/$11.95 Can	X ___ = ___	
47162-9	People of the Bible	$8.95/$11.95 Can	X ___ = ___	
47005-3	People of the Bible (hardcover)	$13.95/$19.95 Can	X ___ = ___	
26768-1	Sharks, Whales, and Other Sea Creatures	$8.95/$11.95 Can	X ___ = ___	
14154-8	Vehicles	$8.95/$11.95 Can	X ___ = ___	
	Shipping and handling	**(add $2.50 per order)**	X ___ = ___	
		TOTAL	___	

Please send me the title(s) I have indicated above. I am enclosing $_____.
Send check or money order in U.S. funds only (no C.O.D.s or cash, please). Make check payable to
Doubleday Consumer Services. Allow 4 - 6 weeks for delivery.
Prices and availability are subject to change without notice.

Name:_____

Address:_____ Apt. # _____

City:_____ State:_____ ZIP Code: _____

Send completed coupon and payment to:
Doubleday Consumer Services
Dept. LA 21
2451 South Wolf Road
Des Plaines, IL 60018

LA 21-7/96